SYMBOLS OF THE CHRISTIAN FAITH

SYMBOLS OF THE CHRISTIAN FAITH

Alva William Steffler

William B. Eerdmans Publishing Company
Grand Rapids, Michigan / Cambridge, U.K.

© 2002 Wm. B. Eerdmans Publishing Co.

All rights reserved

Wm. B. Eerdmans Publishing Co.

255 Jefferson Ave. S.E., Grand Rapids, Michigan 49503 /

P.O. Box 163, Cambridge CB3 9PU U.K.

www.eerdmans.com

Printed in the United States of America

08 07 06 05 04 03 7 6 5 4 3 2

Library of Congress Cataloging-in-Publication Data

Steffler, Alva William, 1934-

Symbols of the Christian faith / Alva William Steffler.

p. cm.

Includes bibliographical references and indexes.

ISBN 0-8028-4676-9 (pbk.: alk. paper)

1. Christian art and symbolism. I. Title.

BV150.S77 2002

246'.55 — dc21

2001058456

Most of the citations of Scripture in this publication are from the New Revised Standard Version Bible, copyright © 1989 by the Division of Christian Education of the National Council of Churches of Christ in the U.S.A., and used by permission.

In loving memory of
Ruth Aldine Steffler,
wife and best friend for forty-four years

Contents

Contents

Introduction

All language (including visual language) about God must, as St. Thomas Aquinas pointed out, necessarily be analogical. The fact is that all language about everything is analogical; we think in a series of metaphors. We can explain nothing in terms of itself, but only in terms of other things.

DOROTHY SAYERS

Dorothy Sayers makes an important point about how we use language, especially language about God and faith. We rely on the language of metaphors and symbols because they help us to comprehend the truths of our faith and to understand our mysterious God, who cannot be described or known through the limited range of propositional statements we have. Christ himself taught spiritual truths through symbols, most notably using the bread and wine of the Last Supper to teach the mystery of his own Passion. Symbols help us to understand some of the paradoxes of the very nature of Christ. For example, he is presented as both lamb and lion. Other symbols of Christ are just as diverse: he is the cornerstone, the foundation, the rock; he is the living water; he is the vine. These are part of the larger symbolic vocabulary we find in the pages of Scripture.

In this book I have explored this vocabulary and provided renderings of the most prominent symbols, as well as descriptions of many more. My goal is to provide meaningful models for those who are in-

volved in the important task of designing art for the church — art that can be used as an aid to worship as well as instruction.

A natural place for designers to start is by creating works that focus on the major themes of the church calendar. In this regard, there is a wealth of inspiring images that have come from art history and have become part of the established traditions in the church. I have sought to refresh these images in contemporary graphic ways. In addition to creating works based on the major themes of the church calendar, designers may want to invent works that support the theme of a sermon or a series of sermons. To assist in accomplishing this task, I have supplied an index of Scripture references. This kind of accessibility is also the rationale for organizing the first section of the book along the lines of the Apostles' Creed — the well-known creedal statement shared across time and denominational boundaries. The symbols that do not lend themselves to visualization or are tangential to a major symbol are listed and explained in glossaries.

As an artist, I have been encouraged by the church's reawakening to the power of the visual arts in its life. It has been most gratifying for me to find a local congregation and pastor united in encouraging and supporting creative work done to aid in worship and instruction. So I want to say thank you to Immanuel Presbyterian Church in Warrenville, Illinois, and its founding pastor, Reverend Robert Harvey. I dedicate this book to you, my church family.

— I —

Symbols Associated with the Apostles' Creed

The Apostles' Creed

I believe in God, the Father almighty,
* creator of heaven and earth;*

I believe in Jesus Christ, his only Son, our Lord.
* He was conceived by the power of the Holy Spirit,*
* and born of the Virgin Mary,*
* He suffered under Pontius Pilate,*
* was crucified, died, and was buried.*
* He descended to the dead.*
* On the third day he rose again.*
* He ascended into heaven,*
* and is seated at the right hand of the Father.*
* He will come again to judge the living and the dead.*

I believe in the Holy Spirit,
* the holy catholic Church,*
* the communion of saints,*
* the forgiveness of sins,*
* the resurrection of the body,*
* and the life everlasting. Amen.*

God the Father

I believe in God, the Father almighty,
creator of heaven and earth.

HAND

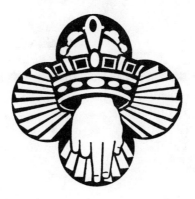

The primary physical representations of God the Father are a hand and an eye. In early Christian art, the hand of God the Father was shown appearing from a cloud, usually with the fingers gesturing a blessing. In Scripture, the hand is used as a symbol for God's power. The Hebrew word *yad* is used for both "hand" and "power" (Josh. 4:24; Job 12:10; Ps. 31:5; Isa. 14:26-27; 40:12; Jer. 18:6; Dan. 4:35). The hand is also used as a metaphor for support and security (Isa. 41:10; Matt. 4:6) as well as favor (Deut. 33:3; 1 Kings 18:46; Ezra 7:9; Neh. 2:8; Ps. 80:17; Acts 11:21). But it is also a symbol of judgment, vengeance, and punishment (Job 19:21; Isa. 5:25; Heb. 10:30-31). The hand of God creates and protects, but if it is thwarted, it also destroys. The right hand of God is the hand of blessing, and the left hand, the hand of cursing.

EYE

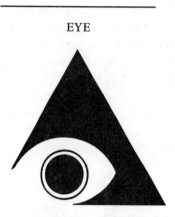

In Renaissance art, the eye was framed in a triangle to signify the Trinity. In Scripture the eye is used as a reference to God's omnipotence, omniscience, and omnipresence (2 Chron. 16:9; Pss. 11:4; 94:9; Jer. 16:17; Zech. 4:10; Heb. 4:13). The eye also symbolizes God's watchfulness and favor (1 Kings 8:29; 2 Chron. 6:20, 40; Pss. 33:18; 34:15; 121:3-5; Prov. 22:12).

FIRE

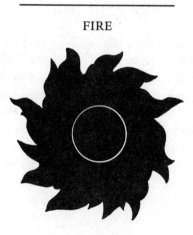

In the Old Testament, fire represents the presence of God in his glory (Exod. 3:2; 13:21-22; 14:19, 24; 19:18; Lev. 6:12-13; 1 Kings 18:38; Neh.

9:12; Ps. 104:4). In the New Testament, fire represents the presence of God in the Holy Spirit. (See the entry below for the Holy Spirit.) Fire is also used as a metaphor for cleansing (Isa. 6:6-7) and spiritual power (Ps. 104:4). In addition, it represents an instrument of testing and judgment (Exod. 9:23-24: Lev. 21:9; Deut. 4:24; 9:3; 32:22; Ps. 106:18; Isa. 33:14; Jer. 20:9; 29:22; Joel 2:3; Amos 1:4-14; 2:2; Mal. 3:2; Matt. 3:10-12; Luke 12:49; 1 Cor. 3:13; Rev. 3:18). Fire figures in the destruction of Sodom and Gomorrah (Gen. 19:24-25), in the final destruction of the world, and ultimately in the description of hell itself as a lake of fire (Rev. 20:14).

CLOUDS

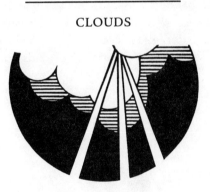

Clouds represent the presence of God (Exod. 13:21; 19:9; 24:15-16; Matt. 17:5; Mark 9:7; Luke 9:34-35). When God led the Israelites through the desert, he was present to them "in a pillar of cloud by day, . . . and in a pillar of fire by night." Clouds are also associated with Christ's ascension (Acts 1:9) and his Second Coming (1 Thess. 4:17; Rev. 1:7).

CROWN

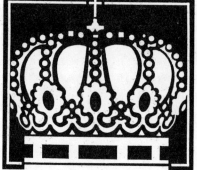

The crown symbolizes both earthly and divine sovereignty, honor, and victory (Esther 2:17; Rev. 4:4). Occasionally, as depicted in the illustration of the hand above, the hand of God extends out of a crown.

HEN AND CHICKS

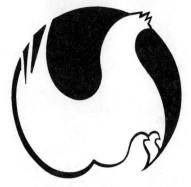

God the Father's protection and care for his children is sometimes expressed in maternal terms. In the New Testament, he is likened to a hen looking after her brood of chicks (Matt. 23:37; Luke 13:34).

WHEEL

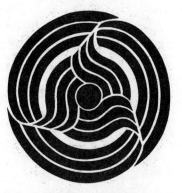

The wheel as symbol is derived from Ezekiel's vision of the throne of God carried on flaming wheels (Ezek. 1:1-28) and Daniel's similar vision (Dan. 7:9). The wheel was used on early Christian gravestones as a symbol of God and eternity.

Jesus Christ

I believe in Jesus Christ, his only Son, our Lord.

LIGHT, CANDLE

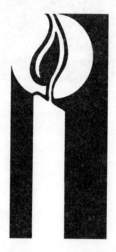

In Old Testament times, light came to signify God's presence and holiness (Ps. 27:1; Isa. 9:2; 2 Cor. 4:4-6; 1 Tim. 6:16; 1 John 1:5). In the New Testament, the children of God are identified as "children of light" and bearers of light (Matt. 5:14-16; John 12:36; Eph. 5:8; 1 Thess. 5:5). In many early paintings, light or the source of light suggests divine presence. In many depictions of the Annunciation, a beam of light enters Mary's ear as a symbol of God impregnating Mary by his divine Word.

Light is also a primary symbol for Christ, the illuminator of God to man, the "Light of the world" (John 1:4). This symbol is used extensively by John in his Gospel (1:4-5, 7-9; 3:19-21; 8:12; 9:5; 12:35, 46). Christ as the Light of the world is often symbolized by a candle. In church furnishings it is common to place a candle on each side of the altar or communion table to signify the two natures of Christ — divine and human. These two sources of light combine at the central illuminated space where the Eucharistic cup and bread are placed.

FISH

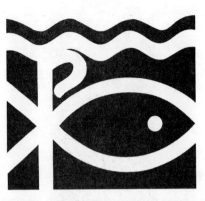

In the early years of the church, believers called themselves "sons of the celestial Ichthus" (Greek for *fish*). In the second century, Tertullian wrote, "We small fish, like our Fish, Jesus Christ, swim in the [baptismal] water, and we can be saved only by remaining in it." The baptismal font is a piscina, which literally means "fishpond." In the third century, Cyprian wrote, "It is in the water that we are re-born, in the likeness of Christ our Master, the Fish." The fish became a common sign used by persecuted Christians to identify themselves as believers — a secret sign of faith.

Another link between faith and the fish symbol is seen in the Greek word *ichthus*, spelled Iota Chi Theta Upsilon Sigma. This is an acrostic for "Jesus Christ, of God, the Son, the Savior": Iesous (Jesus) CHristos (Christ) THeou (of God) Uiou (the Son) Soter (the Savior).

The fish, like some of the other chief symbols for Christ, had a dual symbolic meaning: it could also represent Satan. This reverse meaning has its roots in the books of Job and Isaiah, which designate the monstrous king of the sea as Leviathan, who "makes the deep to boil like a pot" (Job 41:31) and merits God's judgment: "On that day the Lord . . . will punish Leviathan the fleeing serpent, Leviathan the twisting serpent, and he will kill the dragon that is in the sea" (Isa. 27:1).

DOLPHIN

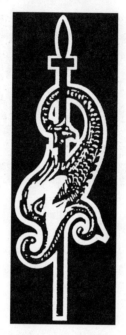

By the end of the second century, the dolphin appeared as a symbol of Christ as guide and friend. The dolphin represented the rescuer of the shipwrecked and the guide of ships through storms and darkness to safe harbor. The early Christians identified the dolphin as the "great fish" that swallowed Jonah, an event that prefigures Christ's death and resurrection. Because it is swift and strong, the dolphin continues to symbolize resurrection and salvation.

GATE, PORTAL

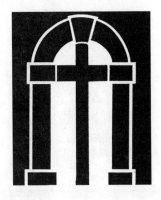

The gate, gateway, or portal is associated with the entry into a place of great importance. In John 10:9, Christ refers to himself as the gate to salvation. See also "Door" and "Threshold" below.

GRIFFIN

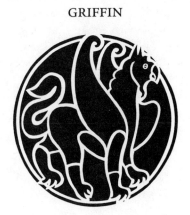

The griffin is a creature of fantasy, important for its domination of both earth and sky. This mythical creature has a lion's body and an eagle's head and wings. In medieval times, the griffin represented Christ's power. Dante used the griffin as the symbol of Christ, possibly because

of its dual qualities, qualities that allude to Christ's dual nature (divine and human) and to his mastery of earth and sky.

LAMB

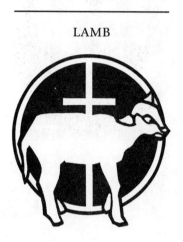

Christ is the Lamb of God, who takes away the sin of the world (Isa. 53:6-7; John 1:29; Acts 8:32; 1 Pet. 1:19; Rev. 5:6, 12; 6:16; 7:9-10; 14:1; 17:14; 19:7; 21:9, 14, 23). The lamb is the principal element in several representational variations with other elements — it is shown with a cross, with a cruciform halo, with blood flowing into a chalice, and with the banner of the Resurrection.

RAM

The ram, the male sheep, is a symbol of sacrifice to God. It was the replacement for the human sacrifice of Isaac by his father Abraham (Gen. 22:1-14) and prefigured Christ, who was slain in place of sinful humanity. The ram, like the sacrificial lamb, became the symbol for Christ as victim.

SHEPHERD

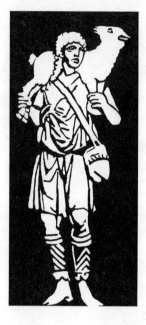

Christ as the Good Shepherd (John 10:11-18) is a beloved theme in Christian literary and pictorial imagery. The designation of spiritual leaders as shepherds or pastors has its roots in the Old Testament (Ps. 23). They learn the shepherd's manner of ministry because their Lord was "the great shepherd of the sheep" (Heb. 13:20; 1 Pet. 5:4).

LION

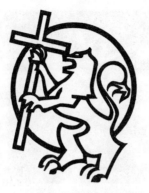

The lion is one of Christ's messianic titles (Gen. 49:9; Rev. 5:5). The lion holding the cross (shown here) was used in medieval heraldry. Like the eagle, the lion represents royal dominion, and thus was adopted as a symbol by Alexander the Great, Maximillian-Hercules, Probus, and Gallienus. The lion also symbolizes strength and courage, and thus was adopted as the insignia of the Roman legions around the time of Christ. In addition, the lion represents justice because of the biblical description of Solomon's throne of justice, which rested on six steps guarded by twelve magnificent lions (1 Kings 10:18-20). However, the lion can also symbolize negative figures like the Antichrist and Satan (Ps. 91:13; Isa. 27:2-3; 1 Pet. 5:8).

SUN

The psalmist describes God as "a sun and shield" — the source of favor, honor, and all good things (Ps. 84:11). Later Malachi announces, "The sun of righteousness shall rise, with healing in its wings" (4:2). This is a prophecy of the salutary effect of Christ's coming — the triumph of good over evil. Depictions of Christ as the Sun God appear as early as the fourth century in the catacombs of Rome.

VINE

The vine is an Old Testament symbol of prosperity and peace among God's people (Ps. 80:8-11; Isa. 27:2-3). In the New Testament, Christ refers to himself as the true vine (John 15:1-11) that believers depend on. In Christian iconography, the fruitful vine symbolizes the union of Christ with his followers.

The Incarnation

He was conceived by the power of the Holy Spirit.

WHEAT/BREAD

Wheat offers a rich store of symbols ranging from messages about the earth's abundance to representations of the incarnation of Christ. As the fundamental ingredient in bread, it represents the bread of the Eucharist, called the host, which is shown in the illustration here. (The head of the wheat stalk is sometimes used as a symbol for the Virgin Mary, since she contained the seed that provided flour for the bread of communion, which is Christ's body. Mary is depicted wearing a garment patterned with wheat heads, like a field where Christ, the wheat, can grow.) In early Netherlandish art, altarpieces of the Nativity often feature a sheaf of wheat as a symbol of Christ, who is "the bread of life" (John 6:32-40). During the Middle Ages, the wheat germ was considered a symbol of Christ, who died, was buried (planted), and then rose to new life.

Bread is a symbol of God's provision of life (Exod. 16:4-15; John 6:36). More specifically, it is a reference to Christ, "the bread of life." It is interesting to note in this connection that Christ was born in the town of Bethlehem, which in Hebrew means "house of bread." Bread also represents the body of Christ, recalling his words when he instituted the Eucharist at the Last Supper (Matt. 26:26; Mark 14:22; Luke 22:19).

DAISY, VIOLET

The daisy and the violet were used as visual references to the Incarnation of Christ during the fifteenth century (a Renaissance device). The daisy, which can be seen in paintings of the Adoration, is a symbolic reference to the innocence of the Christ child. Similarly, the violet is a symbol of humility and is therefore associated with the infant Jesus (Phil. 2:7). It too is found in paintings of the Adoration and the Virgin Mary with the Christ child.

HOLLY

Holly, the symbol of Christmas, represents immortality. The reference finds its origins in the legend which suggests that when the Holy Family was fleeing Herod's soldiers, they took refuge beneath a holly tree that concealed them. It is said that Mary blessed the tree and declared that it would be forever green. Another legend says that the Cross was made of holly wood.

ADVENT WREATH

The Advent wreath represents a synthesis of both of the above legends about holly. The wreath, made with a ring of prickly holly branches resembling the thorny crown of Christ, symbolizes both the birth and the crucifixion of Christ.

DAYSTAR

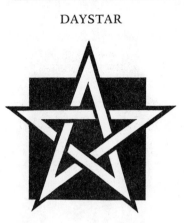

What is commonly called the daystar is a reference to the Advent of Christ the Messiah (Num. 24:17; 2 Pet. 1:19; Rev. 22:16). In Advent symbolism, the star represents divine guidance and favor, as suggested by the account of the Magi, who followed the star to the infant Jesus (Matt. 2:2).

SWALLOW

In Renaissance art, the swallow appears in depictions of the Annunciation and the Nativity. Here it serves as a symbol of the Incarnation of Christ. In other instances the swallow symbolizes resurrection because it leaves in the winter and returns in the spring.

Mary, Mother of Christ

And born of the Virgin Mary

LILY, FLEUR-DE-LIS

Various flowers represent the Virgin Mary in her purity and her sorrow.

For the Christian world, the white lily is a symbol of the purity and virginal love associated with Mary. In depictions of the Annunciation, Gabriel comes to her with a lily in his hands or in a vase. The fleur-de-lis, a variant of the lily symbolizing Mary's purity, adorns the tip of Gabriel's scepter in certain Annunciation scenes. (The fleur-de-lis is also associated with the Holy Trinity.)

Occasionally, Mary's husband Joseph and her parents, Joachim and Anne, are depicted with the lily. And later the lily appears as an attribute of virgin saints — Saint Catherine of Siena, Saint Clare of Assisi, Saint Euphemia, Saint Scholastica, Saint Anthony of Padua, Saint Dominic, and Saint Francis of Assisi. In scenes where the Christ child offers a spray of lilies to a saint, the flowers are a symbol of virtue and chastity.

ROSE

The white rose without thorns is a symbol of Mary, derived from the belief that Mary was without taint of original sin, as the rose was without thorns when it grew in the Garden of Eden. In the Middle Ages, the Madonna was frequently depicted surrounded by roses.

ROSE WINDOW

In medieval churches, the rose window, like the rose, was closely associated with the Virgin Mary. Other symbolic connotations include eternity and the eye of God. The latter is significant because the main body

of the church is designated as the nave, meaning "ship," and so the circular rose window in it becomes its guiding eye. The window, both as an eye looking outward and as a filter of the inward, is an expressive symbol of Divine Light.

SHELL

The shell is a symbol of the Virgin Mary because she carried Jesus, the precious pearl, in her womb. During the Middle Ages, it was believed that the mussel was fertilized virginally by dewdrops. The shell also became a symbol of Christ's sepulchre and of the Resurrection. Because of these interpretations, it became customary to bury a mussel with a deceased believer as a sign of future resurrection from the dead. In Christian iconography, John the Baptist is shown pouring water from a shell onto Christ's head. By the nineteenth century, silver and mother-of-pearl baptismal scallop shells were in common use.

MOTHER OF GOD ENTHRONED

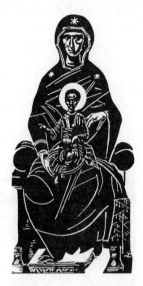

Another representation of Mary, this one not derived from nature, is *Theotokos,* from the Greek *Theos,* meaning "God," and *tikto,* meaning "to give birth to." *Theotokos* functions as a title for the devotional icons of the Virgin Mary seated on a throne holding the infant Jesus on her lap. The title was bestowed on the Virgin Mary by the Council of Ephesus in A.D. 431.

The Cross

*He suffered under Pontius Pilate,
was crucified, died, and was buried.
He descended to the dead.*

CROSSES

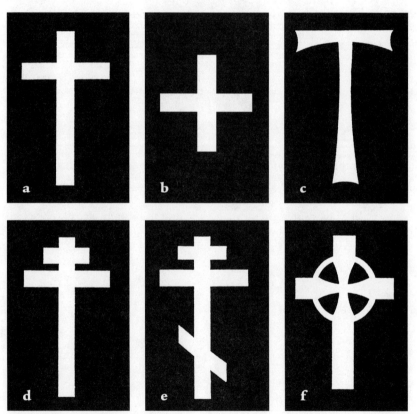

The cross, the most significant symbol of Christianity, recalls the redemption of humankind through Christ's sacrificial death. As a Christian symbol, the cross is found on sarcophagi, lamps, and other objects beginning around the fifth century. At this time it began to replace the Chi Rho monogram as the major symbol for Christianity. (See the entry for "Chi Rho" below.)

There are approximately four hundred variations on the basic shape of the cross (a long vertical post intersected at right angles by a shorter horizontal post). The most common are the Latin cross, with the intersecting horizontal post about three-quarters of the way up the vertical (see figure a); the Greek cross, in which the horizontal post bisects the vertical (see figure b); the Tau or Advent cross, which is shaped like the letter "T" (see figure c); the Patriarchal cross, which has two graduated transverse arms (see figure d); the Eastern Orthodox cross, which has two horizontal arms and a third slanted arm (see figure e); and the Celtic cross, which has a circle enclosing the cross beams (see figure f).

The cross is seen as a sign of complete resolution between the vertical life force and the horizontal death or "rest" force. Perhaps most importantly, it represents life's polarities: the spiritual or otherworldly (vertical) and the physical or worldly (horizontal).

In many Christian traditions, the sign of the cross, the holiest of signs, is made with a hand gesture from forehead to breast, then from shoulder to shoulder. The sign of the cross is made before prayer in order to collect and compose oneself and to fix the mind upon God. It is made after prayer in order that one may hold fast the gift received from God. In temptation it is signed to give strength, and in danger, protection. The sign of the cross is made in blessings so that the fullness of God's life may flow into the soul.

The narrative of the Cross, or the Stations of the Cross, includes fourteen scenes representing the stages of Christ's Passion and death: (1) Jesus is sentenced by Pilate; (2) He is given the Cross to carry; (3) He stumbles; (4) He meets his mother; (5) Simon of Cyrene is ordered to carry the Cross; (6) Saint Veronica gives Jesus a cloth to wipe his face; (7) He falls a second time; (8) He tells the women of Jerusalem not to weep for him; (9) He falls a third time; (10) He is stripped of his garments; (11) He is nailed to the Cross; (12) He dies; (13) His body is taken down from the Cross; (14) He is laid in the tomb.

SERPENT ON CROSS

A serpent wound around a cross was a symbolic Old Testament reference to Christ on the cross, a parallel drawn by Jesus himself (Num. 21:8; John 3:14). Predating the death of Christ, the cross was a symbol of suffering and self-denial (Matt. 10:38; 16:24; Mark 8:34; Luke 9:23; 14:27).

While the cross is the primary symbol of Christ's suffering and sacrifice, other symbols of the Passion include the crown of thorns, thirty pieces of silver or a bag of coins, a lantern, gall and vinegar, a pillar, a cock, dice, a seamless robe, hyssop, a ladder, a lance, a hammer, and nails and pincers.

TEASEL

In Christian iconography, the prickly plant teasel is used to symbolize the sufferings of Christ and the martyrs. Its thorny stalks recall Christ's suffering under the crown of thorns, the symbol of grief and sorrow (Matt. 27:29; Mark 15:17; John 19:5).

THORNS AND THISTLES

Thorns and thistles are symbols not only of God's judgment on sin (Gen. 3:18; Isa. 5:6) but also of affliction and suffering (Num. 33:55;

l Cor. 12:7 — Paul's thorn in the flesh). Significantly, thorns made up the crown Jesus wore when he was crucified. Thorns also represent the fruit of dead works (Heb. 6:7-8) and the evils that spring from the heart to choke the truth (Matt. 13:7, 22). The unconsumed burning thorn-bush through which the angel of the Lord appeared to Moses (Exod. 3:2-4) became a symbolic representation of Mary's virginity in altar paintings of the fifteenth and sixteenth centuries that depicted Mary and the Christ child in the Burning Bush. Just as the holy fire did not consume what it inflamed, so Mary kept her virginity while becoming a mother.

OX

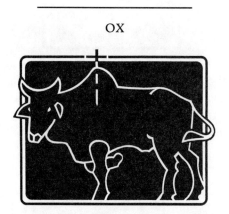

Animals as different as the ox and the pelican symbolize the sacrifice of Christ. The ox was a sacrificial animal (Exod. 29:3, 10-14, 36; Lev. 4:8, 16; Num. 7:87-88; 28:11-31; 29) and in early patristic writing was designated as the symbol of Christ's sacrifice, an alternative to the symbol of the lamb. In Christian art of the Nativity, the ox is shown with the ass. The presence of the ox and the ass confirmed that the Christ child was the promised Messiah (Isa. 1:3; Hab. 3:2). A winged ox symbolizes the Gospel writer Luke, whose writing emphasizes the sacrifice of Christ.

PELICAN

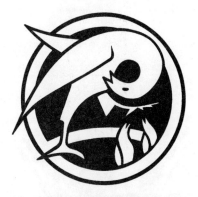

The pelican represents the sacrifice of Christ and the shedding of blood that brings life and healing to sinful humankind (Rom. 5:9; Eph. 1:7). An early Christian writer recounts the fable that the pelican kills its offspring (in other versions they are killed by a serpent), but revives them after three days with blood from the self-inflicted wound in its breast (Heb. 9:12; 1 Pet. 1:19; 1 John 1:7). The pelican dips its beak into its pouch to extract fish to feed to its young; this may have led to the misperception that the pelican ripped open its breast to offer blood to its young.

The Resurrection

On the third day he rose again.

BANNER

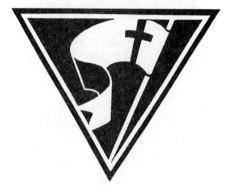

Symbols from the banner to the pomegranate communicate the victory of Christ's resurrection. The banner or flag — usually white, with a red cross — is the symbol of victory over death carried by the resurrected Christ. This symbol derived from the vision of Constantine the Great and his adoption of a cruciform shape on the Roman standard. In Christian art, this banner is usually carried by military saints (Ansanus, Saint George, Reparata, and Saint Ursula) and depicts Christ the Sacrificial Lamb.

BUTTERFLY

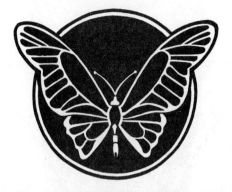

Most of the symbols of the Resurrection derived from nature are linked to spring, a season of new life. For example, the butterfly, a symbol drawn from early mythology, represents resurrection in Christian art. Its life cycle from caterpillar to chrysalis to butterfly symbolizes the life, death, and resurrection of Christ. The Greek language uses one and the same word for the soul and the butterfly: *psyche.* In the western French provinces, the elegantly shaped, bright yellow "Cleopatra" butterfly figures prominently in the symbolism of the resurrected Christ. In some regions it is called the "Easter Jesus" because it appears at Eastertide and is the first butterfly to emerge from its cocoon, as if from the tomb.

POMEGRANATE

Another symbol from early mythology is the pomegranate — a symbol of the Resurrection derived from its classical association with Persephone, who returned every spring to regenerate the earth. The pomegranate, sometimes seen in the hand of the Christ child (as in Fra Angelico's *Adoration of the Magi*), heralds the return of spring and thus foretells his resurrection. In baroque art, the image of the pomegranate, split open to reveal its numerous seeds, stands for the generosity and boundless love of God the Creator. In this connection, the pomegranate was possibly one of the fruits promised to the children of Israel in the Promised Land (Deut. 8:8). With its countless seeds united in a single fruit, it was a reminder of individual believers united in church community. The red juice of the pomegranate became a symbol for the blood of the martyrs.

EGG

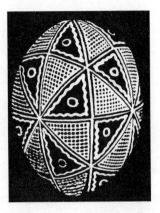

The egg, which in early Near Eastern religions was a spring symbol of creation, revival, and rebirth, has been adopted as a symbol for Easter. It is a Christian symbol of the Resurrection because the small chick breaks from the egg at its birth, just as Christ broke forth from the tomb. The egg, like the seed, contains the promise of new life and hope. The egg also represents chastity and purity, since the chick is protected within the shell.

The ostrich's egg is a dual symbol. It came to represent the Virgin Birth of Jesus because of Job's comment that the ostrich lays its eggs in the earth and leaves them to hatch themselves (39:13-14). Through the belief that the sun hatched the eggs of the ostrich, the egg also became an analogy for Christ's resurrection from the tomb. From the Middle Ages onward, church inventories mention the placement of an ostrich egg on the altar on holy days such as Easter and Christmas. Even today, in many Coptic churches, the ostrich egg figures into the symbols related to the crucifixion and resurrection of Christ. Sometimes a symbolic egg is hung at the feet of the crucified Christ; a noteworthy example is in the Burgos Cathedral in Spain.

On Holy Saturday the medieval church blessed the eggs that would be eaten by the believers the next day, before any other food was eaten. Many Orthodox churches still use Easter eggs that are blessed and painted red. Those given to important people are often elaborately decorated, as in the illustration here.

GOURD

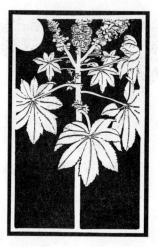

Two interesting symbols of the Resurrection are the gourd and the phoenix. The gourd represents the Resurrection because God caused a gourd to spring up and shade Jonah and deliver him from his grief (Jon. 4:6). The *Palma Christi* or castor-oil plant is held to be the "gourd" of Jonah. In religious art, the gourd represents (and also functions as an attribute of) pilgrims and pilgrim saints. In addition, the resurrected Christ on the road to Emmaus is shown dressed as a pilgrim and sometimes wearing a water-gourd.

PHOENIX

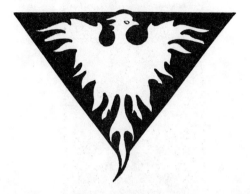

The phoenix is a mythological bird that symbolizes Christ and the Resurrection — the overcoming of death (1 Cor. 15:20-22). The phoenix was part of ancient lore, but the current story of this fantastic bird comes primarily from Egyptian culture. Its life span was believed to be between three hundred and five hundred years. Periodically it sacrificed itself on the flames of an altar, then rose again, young and beautiful, from the ashes. In Christian art, the phoenix frequently appears as a resurrection motif on gravestones.

Christ Triumphant

He ascended into heaven,
and is seated at the right hand of the Father.
He will come again to judge the living and the dead.

PANTOCRATER

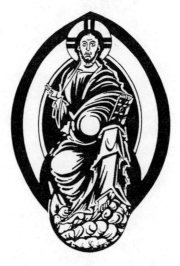

Pantocrater is a Greek word meaning "all-sovereign, ruler of all." As early as the sixth century, the word and related images based on the word came to refer to Christ as Judge (Matt. 19:28; 25:31; Acts 17:31; Rom. 2:16; 14:10; 2 Cor. 5:10). In most depictions of the Sovereign Christ, he is heavily bearded and long-haired. His right hand is raised in blessing or points to the Gospel book in his left hand. Behind his head is a cruciform halo, sometimes with "IC XC" or "A and Ω" in it. (See the entries in the chapter on sacred monograms and shapes.)

FOOTSTOOL

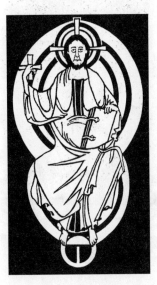

The footstool is a figurative place of submission where the conquered belong; "footstool" is also used to describe the conquered enemy (Ps. 110:1; Isa. 66:1; Luke 20:43; Acts 2:35; Heb. 10:13). In the accompanying illustration, Christ is shown sitting on a throne and placing his feet on the footstool of the earth, which is divided into three sections: earth, sky, and sea.

The Holy Spirit

I believe in the Holy Spirit.

DOVE

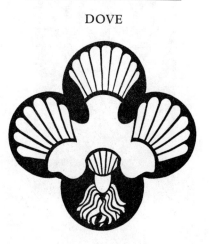

The dove is the primary symbol of the Holy Spirit (Matt. 3:16; Luke 3:22; John 1:32) because the Holy Spirit was present as a dove at the baptism of Christ. In Christian art, the dove is depicted in representations of the Trinity and the Annunciation. In the Old Testament, the dove, with an olive branch in its mouth, became a symbol of the peace God made with humankind in the story of Noah's Ark (Gen. 8:11). The dove also became a symbol of man making peace with God when it was offered as a sacrifice, as depicted in scenes of the purification or Jesus' presentation in the Temple. The dove was one of the few birds permitted to be offered as a sacrifice under Mosaic Law (Lev. 1:14-17; 5:7-10; 12:6-8; 14:22; Num. 6:10).

Medieval art uses the dove to refer to the seven gifts of the Spirit ("the spirit of wisdom and understanding, the spirit of counsel and might, the spirit of knowledge, of godliness, and the fear of the Lord"; Isa. 11:2). In the New Testament, twelve doves symbolize the fruit of the Spirit ("love, joy, peace, patience, benignity, goodness, long suffering, mildness, faith, modesty, continency, chastity"; Gal. 5:22-23).

40

In common usage, the dove symbolizes the soul departing at death, either leaving the body (seen in Russian and Greek Orthodox icons depicting the Dormition of the Virgin) or leaving the lips of saints. The departure of the dove symbolizes death, but the presence of the dove pecking at bread or drinking from a fountain represents the soul nourished by the Eucharistic bread and cup.

FIRE, TONGUES OF FIRE

Fire is a symbol associated with both the Holy Spirit and God. In the Old Testament, fire represents the presence of God in his glory. In the New Testament, fire is a symbol of the presence of God the Holy Spirit (Matt. 3:11; Luke 3:16). The tongues of fire that came down on the Apostles at Pentecost symbolize their being filled with the Holy Spirit (Acts 2:3).

TORCH, CANDLESTICK

The seven torches in Revelation are symbolic of the seven powers or spirits of God (Rev. 4:5). The seven-branched candlestick of Israel is used by some traditions to represent these powers. A torch is also the attribute of martyrs tortured with a torch (Saint Eutropius and Saint Dorothea). Prior to Christian usage, the torch was an attribute of various pagan gods and a symbol of life to the Greeks. In Renaissance funerary sculpture, the torch was a symbol of death.

COLUMBINE

Just as the seven torches symbolize the seven powers of God, so the seven blooms of the columbine symbolize the seven gifts of the Spirit of the Lord (Isa. 11:1-2). Columbine means "like a dove" because its flowers were thought to resemble doves in flight. Because of this association, it became a symbol of the Holy Spirit, who descended in the form of a dove (Luke 3:21-22; John 1:32).

WIND

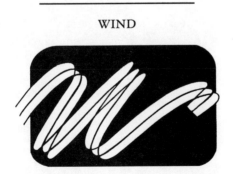

Using a metaphor full of mystery, Jesus likened his Spirit to the wind, which blows where it pleases according to the plan of God. Christ brings new life to everyone born of the Spirit (John 3:8).

The Holy Catholic Church

I believe in the holy catholic Church.

SHIP

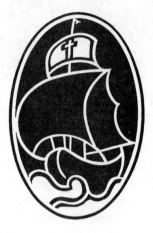

Early church fathers likened the church to a ship where the believer found safety and was borne along to salvation. The metaphor of the church as a ship in which the faithful safely move through worldly dangers to eternal life recalls the protection of Noah's Ark. Saint Hippolytus referred to the world "as a sea in which the Church, like a ship, is beaten by the waves but not submerged." Peter, as head of the church, is often depicted as the helmsman of a ship. The literal church building is also compared to a ship, with the tower as the mast and the buttresses as the oars.

TYMPANUM

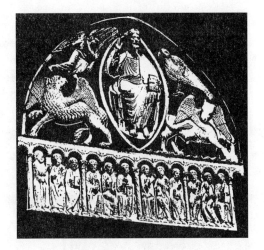

The structure and furnishings of the church are rich with meaning. The tympanum is one of many examples. In medieval architecture, the tympanum was the space within the arch above the lintel over the west doorway. The Last Judgment was depicted within the arch. As worshippers passed through this doorway, the image reminded them of the salvation from judgment they found in the Church. (See the entries for "Threshold" and "Door" below.) Shown here is a representation of the tympanum on the west facade of the cathedral at Chartres.

BAPTISMAL FONT

Historically, baptism has been regarded as an act of both purification and rebirth. In many Christian traditions, baptism is considered the rite of initiation into the church. Consequently, the font, which contains holy water for baptism, stands at the entrance (the west end) of a church or in a separate baptistry, and welcomes the worshipper with the promise of new life. Tradition dictated that the font have eight sides, because the world was created in seven days, and the eighth day is the Day of Regeneration.

EUCHARISTIC ELEMENTS

At the front of the church, the altar and all the instruments of the Eucharist stand as symbols of God's forgiveness and his continuing redemption and sanctification. Together the bread and the wine are the principal elements of the Eucharist (Matt. 26:26-28; Mark 14:22-24; Luke 22:19-20; John 6:52-56; 1 Cor. 10:21). The Eucharist is prefigured in the Old Testament scene in which Elijah receives food and drink from an angel (1 Kings 19:4-7); likewise, it is prefigured when the priest Melchizedek blesses bread and wine (Gen. 14:18-21).

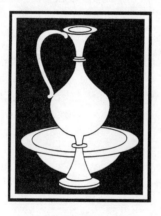

Ewer and Basin

The celebrant of the Eucharist, who wears a cincture (a broad sash or robe tied around the waist, symbolizing chastity), pours water from a ewer into a basin and washes his hands before the celebration. This represents purity, cleanliness, and innocence (John 13:5).

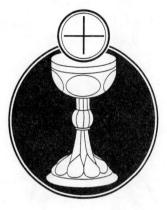

Host and Chalice

The Host, a thin round of unleavened bread, is a symbol of the body of Christ. It is displayed in a container called the monstrance, from the Latin *monstrare,* meaning "to show." The ciborium is the bowl or goblet-shaped vessel with a lid that contains the Host prepared for Holy Communion. (*Ciborium* also refers to the canopy raised over the high altar of the church and supported by four columns — a symbolic suggestion of the Ark of the Covenant in the Old Testament.) During communion, the paten, a plate usually made of precious metal, is used to carry the Host. It symbolizes the dish used at the Last Supper.

Grapes symbolize the wine of Communion and the blood of Christ, the "True Vine." Wine is used figuratively to speak of divine judgments (Pss. 60:3; 75:8; Jer. 51:7) and of the joys of wisdom and faith (Prov. 9:2, 5; Isa. 25:6; 55:1; Joel 2:19). But wine as the "blood of the grape" refers primarily to the blood of Christ. The cup of blood is a symbol of Christ's agony in the Garden of Gethsemane (Matt. 26:39, 42; Mark 14:36; Luke 22:42), and the use of the cup of wine as a remembrance of Christ's shed blood was sanctioned by Christ at the Last Supper (Matt. 26:27; Mark 14:23; Luke 22:20). The chalice or cup is the vessel that bears the consecrated wine of the Eucharist.

Since the Old Testament, the cup has symbolized God's salvation (Ps. 116:13). One sacred chalice called the "Holy Grail" is an important symbol in medieval legend. The literary source of the Holy Grail is the apocryphal Gospel according to Nicodemus, which describes this cup as the one first used by Christ at the Last Supper and used soon there-

after to collect his blood. The Crusaders' pursuit of relics may have helped develop the legend of the Holy Grail.

BELLS

Other elements in the sanctuary used to enhance worship include bells and incense. Bells have had an important function in worship since the early establishment of Hebrew liturgy. Bells fringed the priestly robe of Aaron (Exod. 28:33-34; 39:25-26). At least by the eighth century, bells were used to summon the faithful to worship, tolled at six A.M., noon, and six P.M. (for saying the Angelus), and rung at the passing of a parishioner. Bells continue to be used by the church in these and other ways. In the Roman Catholic tradition and some Episcopal traditions, a small handheld Sanctus bell is rung before the elevation of the Host at the altar. A bell is rung by an acolyte who accompanies the priest taking the sacrament to the sick or dying. In the Orthodox Church, the ringing of bells marks various points in the liturgy.

THURIBLE OR CENSER (INCENSE)

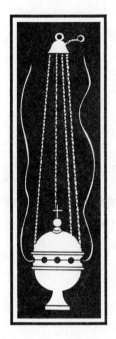

Incense symbolizes the prayers of believers ascending to God (Ps. 141:2; Rev. 5:8; 8:3-4). In the Old Testament Jewish tradition, incense was burned only as a sacrifice to God, and there were strict guidelines concerning the use of incense in the holy place (Lev. 16:12-13). In liturgical practice, incense is burned in a metal vessel called a thurible or censer that is swung to distribute the fragrance. The practice includes censing the celebrant or the altar during blessings or consecrations as a symbol of blessing, consecration, and sanctification. The censer is used in Eastern Orthodox, Roman Catholic, and other churches. (Incense is also used in a different way in more liturgical churches: five grains of incense are inserted into the paschal candle to symbolize the five wounds of Christ. This candle stands near the altar from Easter to Ascension Sunday.)

Thomas Aquinas gave two reasons for the use of incense. The first was to show reverence for the Eucharist by having its agreeable scent dispel any bad smell in the place of worship. The second was to show

the effect of grace, wherewith Christ was filled: "See, the smell of my son is as the smell of a field at harvest. From Christ it spreads the fragrance of the knowledge of him everywhere. So when the altar, which signifies Christ, has been censed, then afterwards all are censed in turn." In 2 Corinthians 2:15 followers of Christ are described as people "in the good odor of Christ" (contrast 2:16). Christ is a sacrifice to God that yields an odor of sweetness.

The Communion of Saints

I believe in the communion of saints.

ARK

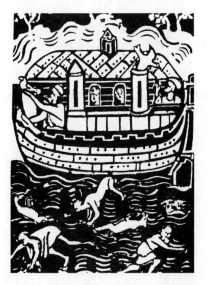

The ark, built by Noah to survive the Flood, became a symbol for the church, the means by which God protects his own (Gen. 6:18; 7:1, 23).

FISHERMAN'S NET, FISH

While the boat protects believers, the fisherman's net is a symbol of catching and gathering (Luke 5:1-11) the lost. God draws the lost to himself through the work of witnessing believers — "fishers of men." The net is an attribute of the disciple Andrew (Matt. 4:18).

FOOT

Feet symbolize God's presence (Isa. 60:13) and also virtues of believers, including humility, willing servitude and submission (Ruth 3:4, 7, 14; Isa. 49:23; 52:7; Ezek. 2:1-2; 3:24; Matt. 28:9; Luke 7:38; Acts 4:35, 37; 5:2; Rev. 1:17; 19:10; 22:8), and discipleship (Deut. 33:3; Luke 10:39; Acts 22:3). The washing and anointing of feet is an act of devotion, humility, and cleansing (Luke 7:38; John 11:2; 12:3; 13:5; 1 Tim. 5:10). Feet are also a symbol of life's pilgrimage (Pss. 119:105; 122:2; Prov. 1:15-16; 4:26; 5:5; 6:18; 7:11). In addition, foot and feet are also used to symbolize the evangelists, messengers of God's good news (Isa. 52:7; Rom. 10:15; Eph. 6:15).

STAFF, ROD

The staff, together with the rod, is a symbol of divine protection and guidance (Ps. 23:4). It is also associated with many saints who have been known for their pilgrimages (James the Great, Saint Christopher, John the Baptist, Saint Jerome, and Philip the Apostle).

ORANT

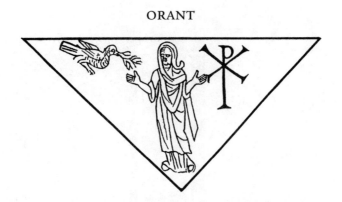

The believer is often pictured in "orant" (from the Latin *orans,* meaning "to pray"). In this symbolic posture of prayer, the hands are raised to the level of the shoulders or head, and the palms are turned upward in a gesture of reception. This may be the oldest posture for prayer, appearing in Callistus's catacomb as early as A.D. 180, and it is still used by priests in the celebration of the Mass. In tombstone art, the deceased are often portrayed in this posture. Icons of the Virgin Mary sometimes portray her in the orant posture.

ARMOR

Believers are also pictured in the more active posture of warriors. From the armor of faith that protects God's people from evil (1 Chron. 10:4; 2 Cor. 6:7; Eph. 6:11-18; 1 Thess. 5:8) to the helmet that is a symbol for the protection of salvation (Isa. 59:17; Eph. 6:17; 1 Thess. 5:8), the metaphors of armor communicate our protected vulnerability.

CHAINS, FETTERS

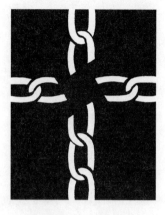

Chains and fetters are symbols of the imprisonment and slavery of believers (Judg. 16:21; Pss. 2:3; 105:17-18; Acts 12:6-7; 21:33; 28:20; 2 Tim. 1:8, 12, 16; Heb. 11:36). They sometimes testify to our entrapment in weakness. But chains also symbolize the binding of Satan (2 Pet. 2:4; Jude 6; Rev. 20:1), and broken chains, like those pictured here, symbolize the overcoming of slavery, the breaking of the bondage of sin. Dionysius the Areopagite (ca. A.D. 500) speaks of the Christian's prayers as a golden chain whose luminescence bridges the abyss between creature and creator.

The Forgiveness of Sins

I believe in the forgiveness of sins.

HYSSOP, BASIN AND TOWEL

Hyssop is mentioned in the Old Testament in association with purification rites (Exod. 12:22; Ps. 51:7), and is consequently associated with spiritual cleansing from sin (Lev. 14:4; 6, 51-52; Heb. 9:19-22). When Jesus was crucified, he was offered a sponge filled with sour wine on a branch of hyssop.

The ewer (a large, uncovered metal pitcher) and basin are used for the washing of the celebrant's hands at the Eucharist — a symbolic act of purification. A hanging towel with a basin is also symbolic of cleansing, as depicted in the Annunciation panel of the *Merode Altarpiece* (ca. 1428), a triptych by Robert Campin. The basin and towel are also symbols of the Passion, a reference to Pilate's washing his hands (Matt. 27:24), as well as to Christ's washing of the disciples' feet at the Last Supper (John 13:4-5).

The Resurrection of the Body

I believe in the resurrection of the body.

CRANE

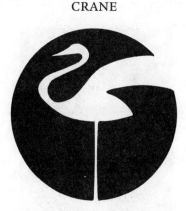

The crane became a symbol of renewal and resurrection in early Christian iconography because its migratory flight announced the coming of spring. The crane is also a model of Christian vigilance. The crane keeps itself awake by standing on one foot and holding a stone in the other. If it nods off, the stone falls and awakens it. The crane's vigilance was extolled by Hohberg in 1675 in his book of emblems: "By night the crane a pebble gripped doth hold,/Lest sleep surprise his watch and close his eyes./So, lest this world should lull with pomp and gold,/The Cross reminds us where our duty lies."

The Life Everlasting

I believe in the life everlasting.

CHERRY

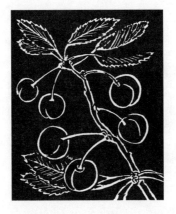

Artists' visions of idealized nature are vividly shown in their depictions of the Garden of Paradise and of heaven. Flowers — the ultimate glorious display of nature — fill scenes of heaven in early Renaissance art. One particularly impressive painting is *The Last Judgment* by Giovanni di Paolo, which shows the elect greeting one another with love in heaven. Because they wax and wane according to the seasons of the year, flowers and fruits suggest the cycle of life, death, and resurrection. In Christian art, flowers and fruits might have a purely decorative function. However, when they figure prominently in the main composition or embellish the borders of a medieval book, they usually have a specific symbolic meaning. See the Glossary of Additional Symbols for descriptions of individual flowers.

FLOWERS

The fragrance of flowers is implied in the depictions of heaven as a garden. Flowers are also used to represent a condition of heaven, as in the Pentecost ceremony in certain churches in which wafers and flowers are dropped on the congregation from the roof during the singing of the hymn "Veni, Creator Spiritus."

IVY, LAUREL

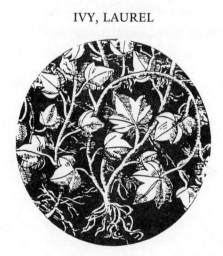

Ivy is a symbol of faithfulness and enduring friendship because of its ability to cling. Medieval Christian symbolists used ivy to symbolize the eternal life of the soul after the death of the body because it clings to dead trees and continues to be green. Similarly, laurel, because it is an evergreen, is a symbol of eternity. In the days of the ancient Greeks, laurel was used to weave festive garlands and crowns. Artists, poets, philosophers, athletes, and conquerors received this symbol of honor and victory. Paul contrasted this crown with the imperishable crown won by running the spiritual race (1 Cor. 9:24-25).

PEACOCK, CYPRESS TREE

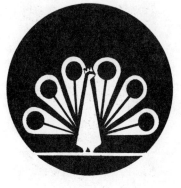

The peacock is a Christian symbol of immortality, adapted from its earlier and more common association with pride (due to its habit of strutting and displaying its magnificent tail feathers). Aristotle maintained that the flesh of the peacock was incorruptible (that it didn't decay after death), something that Saint Augustine verified, making the peacock an appropriate symbol of the promise that we will be raised "incorruptible" (1 Cor. 15:52).

The cypress tree has also undergone an evolution in its symbolism of the cycle of life, death, and burial. There is evidence that the cypress had religious meaning before Greek civilization. The tree would be planted at a burial site to ward off evil spirits, a ritual particularly associated with underworld cults. Because the cypress is a hardy tree, it became a symbol of longevity. It appears in Christian paintings of Paradise and has become a feature of Christian burials: it is extensively used in cemeteries as a hopeful symbol of eternal life.

LIGHTHOUSE

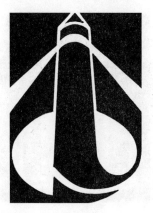

The primary thrust of Christian images of immortality such as the lighthouse, the door, and the city is the promise of a place of rest and safety. In nineteenth-century Romantic Christian art, the lighthouse is a symbol of the heavenly harbor into which the believer sails after a perilous journey.

DOOR

The door represents hope (Hos. 2:15), opportunity (1 Cor. 16:9; Rev. 3:8), and the entrance into the Kingdom of God (Matt. 25:10; Luke 13:25; Rev. 3:8; 4:1). The door may also represent transition to a new state of being, such as the afterlife. In architectural symbology, the three doors of a cathedral stand for faith, hope, and charity.

CITY

In medieval art, a cityscape often refers to the heavenly Jerusalem, the City of God, as described by Saint John in the book of Revelation (Rev. 21:2, 10-27; see also Ps. 46:4; Zech. 8:3; Matt. 5:14; Heb. 11:10; 12:22).

– II –

Sacred Monograms and Shapes

Monograms

MONOGRAMS

Since the days of the early church, groupings of letters have been used to symbolize Christ and God. These combined letters are known as sacred monograms, although several of them are properly called abbreviations.

ALPHA AND OMEGA (A Ω)

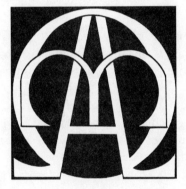

The alpha and the omega, the first and last letters of the Greek alphabet, symbolize Jesus as the beginning and end of all things, and are associated with the Trinity (Rev. 22:13).

Occasionally one of the middle letters of the Greek alphabet — M or N — is included in the monogram, as in the accompanying illustration. This refers to Jesus Christ being the same yesterday, today, and forever (Heb. 13:8).

CHI RHO (XP)

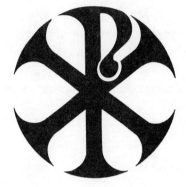

The Chi Rho is a symbol derived from the first two letters of the Greek word for Christ (XPICTOC, pronounced "Christos"). The two letters can be combined in a variety of ways, as the illustration indicates. The Chi Rho has been a symbol of Christianity since the time of Constantine. A banner displaying the Chi Rho is said to have been carried into battle when Constantine fought against Maxentius in A.D. 312. When Constantine was victorious, the prophecy given him came to pass: *"In hoc signo vinces"* — "Under this sign you will be victorious." Used in primitive Christian art, the Chi Rho monogram is commonly found on sarcophagi, Eucharistic vessels, and lamps.

In liturgical churches the Chi Rho symbol is used to designate the pastoral office of the minister because the Greek letter *rho* (P), when stylized, looks like a shepherd's staff. Pastors, shepherds of their flocks, serve under Christ, the Great Shepherd of the sheep (Heb. 13:20; 1 Pet. 2:25).

IC

IC is a monogram made from the first and last letters of the Greek word for Jesus (IHCOYC). This monogram usually appears in combination with XC (from XPICTOC). See the illustration below.

IC XC NIKA

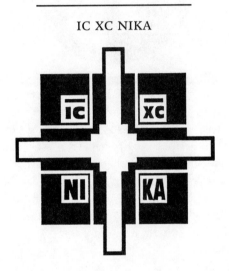

This is the ancient monogram for "Jesus Christ the Conqueror." "IC XC" stands for "Jesus Christ"; NIKA is the Greek word for conqueror. These capitals are often arranged between the arms of a Latin cross in groups of two. Eastern Orthodox icons commonly feature a horizontal stroke above the letters "IC XC," indicating that it is an abbreviation. In Orthodox icons of Christ, his raised right hand signs the letters "IC XC." This monogram signifies Christ's victory over the Cross.

IHC OR IHS

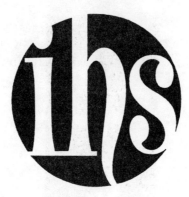

IHC is derived from the first three letters of the Greek word for Jesus (IHCOYC). A Latin interpretation of the letters "IHS" is "Iesus Hominum Salvator," meaning "Jesus the Savior of Mankind." This usage is traced back to Bernardino of Siena (d. 1444), who displayed these letters on a plaque when he preached. The Jesuit community adopted the monogram as their symbol, a mark of their membership in the Society of Jesus. But the original meaning of the monogram is "In hoc signo (vinces)," meaning "In this sign thou wilt conquer." IHS often appears in depictions of Constantine's victory.

IX, XI

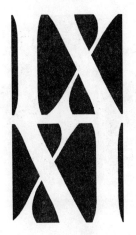

As mentioned earlier, XPICTOC is the Greek word for Christ, and IHCOYC is the Greek word for Jesus. IX is a monogram formed from the first letter of IHCOYC and the first letter of XPICTOC, meaning "Jesus Christ." Occasionally the monogram is reversed as XI, meaning "Christ Jesus." Because we use both designations in speaking of the Son of God, the two versions have been combined as a design that reflects common usage.

INRI

These are the initial letters of the Latin phrase "Iesus Nazarenus Rex Iudaeorum," which means "Jesus of Nazareth, King of the Jews." This is the inscription that Pilate had placed over Jesus' cross (John 19:19). This monogram commonly appears at the highest part of the vertical bar of a crucifix.

Y

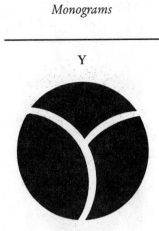

The Greek letter ipsilon, written "Y," sometimes serves as a symbol of the Trinity because it is made of three strokes combined into one figure. It has also been used as a symbol of free will because of the choice of direction offered at the intersection of the figure.

IR

These are the initials for the Latin phrase "Iesus Redemptor," meaning "Jesus Redeemer."

IS

These are the initials for the Latin phrase "Iesus Salvator," meaning "Jesus Savior."

YHWH/TETRAGRAMMATON

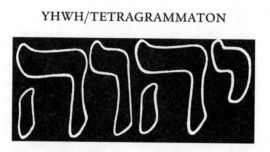

The transliteration of the four Hebrew consonants represents the personal name of Israel's God: Yahweh. The name was so sacred that it was never spoken aloud; saying it would be the equivalent of taking the Lord's name in vain. YHWH is referred to as "the Name" (*ha-sem*), or the word *Adonai,* "my Lord," is used in its place. According to tradition, God revealed the Tetragrammaton to Moses. In current usage, it is written on the amulets in Jewish homes, where it symbolizes God's omnipresence.

Y (YOD)

A letter of the Hebrew alphabet that when placed in a triangle or shown with rays extending from it represents YHWH, the unutterable name of God the Father. Three yods aligned next to each other symbolize the Trinity. Yod is also the first letter of the name of Jesus in Hebrew.

Shapes

CIRCLE, SPHERE, RING

The circle is a symbol of eternity because it has no beginning and no end. The circle was of strong symbolic importance to early humans because of its association with the sun, moon, and stars. In some early Christian manuscripts depicting Christ sitting on the throne in heaven, the earth at his feet is rendered as a circle. (See Isaiah 40:22: "It is he who sits above the circle of the earth. . . .") During the Renaissance, the circle and the sphere were considered the perfect shapes, conforming to Renaissance thinkers' idea of God. He was the cosmic god who took the form of a sphere containing the whole universe — spirit, mind, and matter, depicted in descending concentric circles. Renaissance architects, following the principles of Leon Battista Alberti, reverted to the circle as the basis of design for churches. A strong example is Donato Bramante's Tempietto of San Pietro, built in Rome. In historic Christian symbolism, three circles intertwined refer to the Trinity.

As an architectural device, the sphere or semi-sphere, like the circle or arch, represents the sky or the heavens. (The dome is also an architectural metaphor for the heavens because its interior shape is concave.)

Rings, like circles, are symbols of eternity and permanent union. The wedding ring is a symbol of an unbreakable union. A bishop's ring signifies his union with the church, a nun's ring her spiritual marriage to Christ. Popes, cardinals, and bishops also wear rings as emblems of authority.

ORB

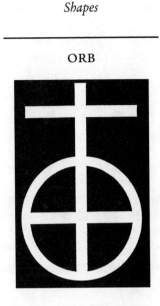

The orb is a globe surmounted by a cross, demonstrating Christ's authority and supremacy over the temporal. The orb is usually held in the hand to symbolize power and authority. Christian kings carried an orb at their coronation. In Christian art, the Christ child is sometimes depicted holding an orb while seated on Mary's lap. Christ as Pantocrator, ruler of the world, is depicted with an orb in his hand.

HALO/NIMBUS

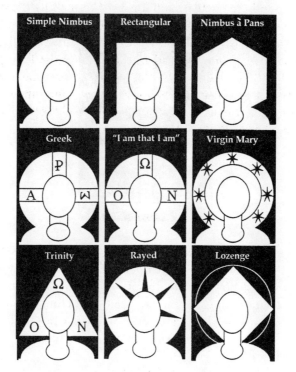

The word *halo* is derived from *helias,* the Greek word for sun, and specifically refers to radiation surrounding the sun and moon. Through common usage it has come to mean the same thing as nimbus (the Latin word for cloud).

The halo is a symbol of holiness, the supernatural, and the mystical. Whereas an aureole surrounds an entire figure, a halo surrounds the head of a figure.

Unadorned circular halos are associated with saints. In the Middle Ages, it became customary to inscribe halos with the names of the saints being portrayed. Hexagonal or lozenge-shaped halos are used in the representation of virtues and in the depiction of allegorical figures as well as Old Testament and pre-Christian personages. The square halo was used to differentiate significant donors to the church and other important people from the saints. (The square is an earthly geo-

metric shape and as such is inferior to the circle of eternity.) In many early frescoes and mosaics, the rectangular halo was used to identify living persons, and the circular halo was used to identify the dead.

The cruciform halo surrounding the head of Christ symbolizes redemption through the Crucifixion (the cross within a circle). Three rays of light emanating from the head are a symbol of the Trinity, as is the triangular halo. The halo of the Virgin Mary is decorated with stars around its outer perimeter. In Orthodox icons, identifying monograms often appear in the halo. For example, *Omicron Omega Nu,* meaning "I am that I am," identifies God the Father.

ALMOND

The almond is a symbol of divine favor, as can be seen in the flowering of Aaron's rod (God's sign that he was choosing Aaron as priest) and God's calling of Jeremiah (Num. 17:1-8; Jer. 1:9-12).

MANDORLA

The mandorla is an almond-shaped aureole or halo (made of two intersecting arcs) that symbolizes the glory surrounding the figures of Mary,

the Trinity, and Christ. It is used in depictions of the Transfiguration and the Assumption of Mary.

TRIQUETRA

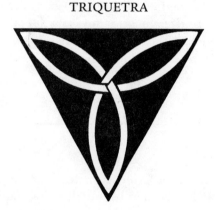

The triquetra is a circle divided into three parts — for example, three interlaced ovals, as in the illustration. It was used as ornamentation on clay pots as early as the late Bronze Age. The triquetra is a symbol of the Trinity, as is the triangle, the number three, and the trefoil.

QUATREFOIL

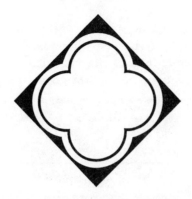

The quatrefoil is a decorative design that consists of a leaf having four foils, or lobes. Most often the figure is symbolic of the Four Evangelists — Matthew, Mark, Luke, John — but it may also be used to symbolize anything in fours. (See the entry for "Four" below.)

OCTAGON

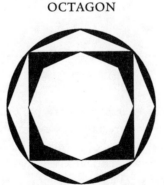

The octagon is an eight-sided geometric figure, the intervening shape between the circle (a symbol of the eternal) and the square (a symbol of the temporal) and therefore a symbol of spiritual regeneration. Most baptistries are constructed in this eight-sided configuration.

SQUARE

The square is a symbol of the earth, in contrast to the circle, which represents the heavens. In design it is the most static, non-dynamic of shapes and is therefore used to suggest balance and resolution. The square indicates the four points on the compass and the four corners of the earth (Isa. 11:12; Ezek. 7:2).

CUBE

As a universal symbol, the cube, the three-dimensional counterpart of the square, is an image of stability and permanence. Plato associated the cube with the "element" earth. In the book of Revelation, the heavenly Jerusalem is described as a cube ("The city lies foursquare"; 21:16). Its dimensions — 12,000 furlongs (1,500 miles) in length, breadth, and height — make it a perfect form based on the number twelve. For the symbolic significance of the number, see the Glossary of Colors and Numbers.

RECTANGLE

As part of the system of "sacred geometry and proportion" in the tradition of icon production, the rectangle, based on the ratio of 4:3, is considered the geometrical symbol of harmony. Early icon painters found this order and proportion essential to conveying the spiritual meaning of the icon. The Greeks called this proportional relationship, manifested in nature, the Golden Section. It demonstrates in its essential geometry the mean between extremes. Expressed in numbers, the golden proportion is 1 to 1.618. Christian artists have related the proportional relationship of the Golden Section to the mystery of God; for this reason it is called the Divine Proportion. God gave important rectangular

proportions for the construction of Noah's Ark (Gen. 6:14-17) and the construction of the Ark of the Covenant (Exod. 25:10-17).

TRIANGLE

In the early years of Christianity, the Manicheans used the triangle as a symbol of the Trinity, which led Augustine (A.D. 354-430) to reject its use. Nevertheless, it ultimately prevailed as a shape that represents the Trinity. The equilateral triangle, with three equal sides forming one shape, has been used since the seventeenth century. A hand, an eye, a head, or the name of God are often depicted in conjunction with the triangle. The eye within the triangle (symbolizing the all-seeing eye of God) was adopted by Masonic guilds to indicate that they were under the protection of the Trinity.

Of the possible orientations of the triangle, the triangle with a horizontal base is used as a symbol of the Trinity. This position conveys a feeling of stability and permanence.

STAR

The star is a symbol of divine guidance or favor, derived from the account of the Magi, who followed the star to the infant Jesus (Matt. 2:1-2). Like grains of sand, stars are a hyperbolic symbol of countless numbers (Gen. 15:5; 22:17; Deut. 1:10; 10:22; 1 Chron. 27:23; Ps. 147:4; Heb. 11:12). The star is used metaphorically to imply dignity and majesty (Job 38:6-7; Dan. 12:3; Rev. 1:16, 20; 2:1; 3:1; 12:1; 22:16).

In Christian iconography, twelve stars may symbolize the twelve tribes of Israel or the twelve Apostles. As the Queen of Heaven, the Virgin Mary is crowned with twelve stars (Rev. 12:1). The star is one of the less common symbols of Christ ("A star shall come out of Jacob" — Num. 24:17; "I am . . . the bright morning star" — Rev. 22:16).

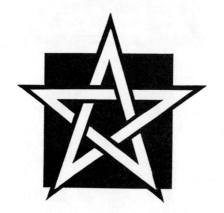

Pentacle/Pentagram

The pentacle or pentagram is a five-pointed star that in Christian iconography is associated with the five wounds of Christ. It is also associated with the Epiphany, representing Christ's manifestation to the Gentiles. As a sign to ward off evil spirits, the pentacle is carved on door frames, thresholds, and gates.

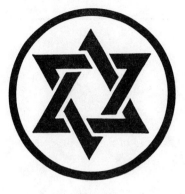

Hexagram

The hexagram is a six-pointed star made of two intersecting triangles. It was believed that King Solomon exorcised demons and summoned angels with this sign. It appears in the early writings and practices of magicians and also has strong associations with Hebrew mysticism.

The hexagram is commonly referred to as the Star of David, the modern symbol of Judaism. According to Jewish interpretation, the joined triangles symbolize the heavenly penetrating the earthly.

SALTIRE

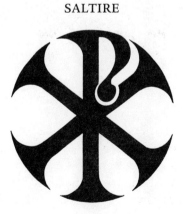

The saltire is a cross in the form of the Greek letter *chi*, X, symbolizing Christ. See the entry for "Chi Rho" earlier in this section.

SWASTIKA

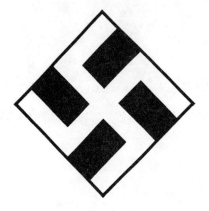

Swastika comes from the Sanskrit *svasti,* meaning "well-being." This cross has four bars of equal length whose ends extend at right angles and face in the same direction, making either a right-hand or a left-hand swastika. This form of the cross has, unfortunately, become most famil-iar as a symbol of Naziism — but it did not have these negative associa-tions in earlier times. The form has been discovered in drawings dating back to prehistoric times and as a solar sign on pottery as early as the third century B.C. This non-Christian symbol was appropriated by early Christians. It appears in the Christian catacombs around A.D. 200.

– III –

*Symbols of the Evangelists,
the Apostles, and the Saints*

Symbols of the Four Evangelists

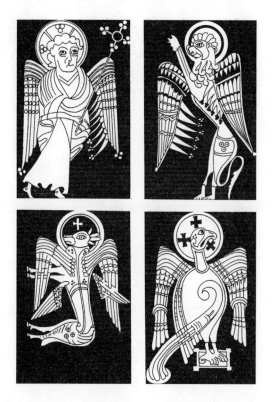

Saint Jerome (c. 347-420), one of the four Doctors of the Church, interpreted the symbolism of the "four creatures" in Ezekiel 1:5-10, Ezekiel 10:14, and Revelation 4:6-7 to represent the four Gospel writers: Matthew, Mark, Luke, and John. Matthew is symbolized by a man because his Gospel begins with the human ancestry of Christ; Mark by a lion, because a lion is the roaring creature of the desert, and his Gospel starts with the story of John the Baptist, "the voice of one crying out in the wilderness"; Luke by an ox, a sacrificial animal, because his Gospel begins with the offering of Zechariah; and John by an eagle, a bird that soars high into the heavens, because his Gospel "soars into the heavens" at its outset.

These representations of the Evangelists are most often seen together in depictions of Christ in the heavens.

TETRAMORPH

The tetramorph is an important figure frequently used in Christian symbolism to represent the Four Evangelists. It shows the man, the lion, the ox, and the eagle united in one body. The creature's description comes from Ezekiel's vision that is later described by John.

Symbols of the Twelve Apostles

A list of the Apostles is found in Matthew 10:2-4: Simon, also known as Peter, and his brother Andrew; James (known as James the Greater) and his brother John, the sons of Zebedee; Philip and Bartholomew; Matthew the tax collector and James the son of Alphaeus (called James the Less); Thaddaeus (also called Jude) and Simon the Zealot; and Thomas ("the Twin") and Judas Iscariot. Matthias was chosen later, after Judas's suicide (Acts 1:26).

Depicting the Apostles and other saints with symbols is a practice that has European roots. The symbols are used most frequently in the Roman Catholic, Episcopalian, and Lutheran traditions. Typically these symbols are placed on shields or banners. Red is usually the background color for those who were martyred; white or blue is the background color for confessors. Each Apostle is symbolized by something that made him noteworthy and/or by the instrument of his execution.

SAINT PETER (SIMON PETER)

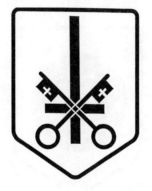

According to legend, Peter was sentenced to die by crucifixion but insisted on being crucified upside down, so as not to rival Christ. Thus he is frequently represented by an inverted Latin cross. He is also represented by the Keys of the Kingdom ("I will give you the keys of the kingdom of heaven" — Matt. 16:13-19).

SAINT ANDREW

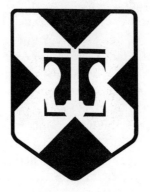

It is said that Andrew was crucified on an X-shaped cross, called a cross saltire. Sometimes an anchor is superimposed on the cross, recalling his original occupation as a fisherman.

SAINT JAMES THE GREATER

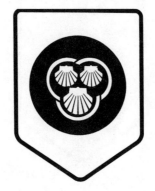

James was the first to go on a missionary journey — to Spain, tradition says. The scallop shell symbolizes his pilgrimage by the sea.

SAINT JOHN

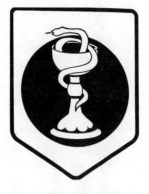

According to legend, an attempt was made to kill John by giving him a poisoned chalice. Thus his symbol is a chalice with a serpent curling out of it.

SAINT PHILIP

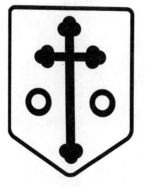

It was to Philip that Christ addressed his remark concerning the feeding of the five thousand ("Where are we to buy bread for these people to eat?"). Philip is also said to have been martyred on a cross. Accordingly, he is often represented by a bishop's cross and two

loaves of bread. (In the illustration shown, the bread is represented by a roundel on each side of the cross.) Variations on this theme include five loaves and two fishes or a basket shape (always combined with a cross).

SAINT BARTHOLOMEW

Bartholomew is represented by three flaying knives placed vertically, since he is said to have been flayed alive.

SAINT MATTHEW

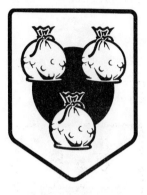

Matthew is represented by three purses or moneybags, a reference to his being a tax collector before he became one of Jesus' followers.

SAINT JAMES THE LESS

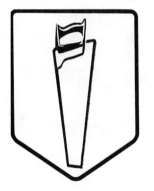

James was supposedly sawn in pieces after he was killed and is appropriately symbolized by the saw.

SAINT JUDE (THADDAEUS)

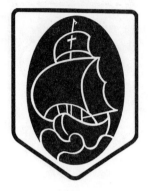

Jude is said to have traveled with Simon on missionary journeys. His symbol is a sailboat with a cross-shaped mast.

SAINT SIMON

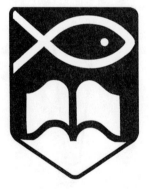

Simon is represented by a fish on top of an open book, because he was a great "fisher of men" when he preached the Gospel.

SAINT THOMAS

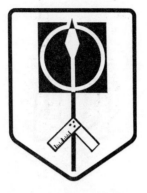

Thomas, the patron saint of builders, is said to have built a church with his own hands in East India — hence the carpenter's square in the illustration. The spear is a reference to the way he was killed.

JUDAS

For obvious reasons, the church never made Judas a saint. He is represented by a blank shield of a dirty yellow color or a moneybag and thirty pieces of silver.

SAINT MATTHIAS

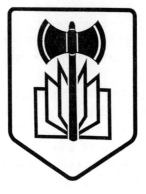

Matthias was chosen by lot to replace Judas Iscariot. He served as a missionary in Judea, where he is said to have been stoned and beheaded. The open Bible symbolizes his call; the battle-ax, his martyrdom.

Significant Symbols of the Saints

AX (HATCHET)

The ax is often a symbol of destruction (Jer. 51:20; Matt. 3:10; Luke 3:9). It became an attribute of martyred saints, notably Saint Jude, Saint Matthias, and Saint John the Baptist. This last association with John the Baptist is amplified by John's summoning the people to repentance, saying, "Even now the ax is lying at the root of the trees: every tree therefore that does not bear good fruit is cut down and thrown into the fire" (Luke 3:9). The ax is also a symbolic attribute of Joseph, the carpenter father of Jesus.

BEEHIVE

The beehive is associated with Bernard of Clairvaux, John Chrysostom, and Ambrose. It indicates their eloquence: honeyed words came from their mouths. The hive is also a representation of the unified, harmonious Christian community.

BLACKBIRD

The blackbird is a symbol of the temptations of the flesh, because it sings a sweet and alluring song even though it is black (representing the darkness of sin). The blackbird became a symbolic attribute of Saint Benedict, who was said to have been distracted from his devotions by the Devil appearing to him in the form of a blackbird.

BOOK

The book is a symbol of learning when held by Bernard of Clairvaux, Catherine of Alexandria, Thomas Aquinas, or other church fathers and founders of religious orders. The book also represents the place of record for human acts (Pss. 139:16; 56:8; Rev. 20:12). Often the Gospel writers are depicted holding their writings. When Mary is depicted holding a book, as she is in Flemish altarpieces, it is usually closed. Tradition has linked this closed book to the reference in Psalm 139:16: "In your book were written all the days that were formed for me, when none of them as yet existed." The other closed book appearing in Christian iconography is the sealed scroll of the Apocalypse, which is to be opened only by the "worthy Lamb" (Rev. 5:1-7). Other important references to the book in Scripture can be found in Exodus 32:32-33; Psalm 69:28; Daniel 12:1; Malachi 3:16; Philippians 4:3; Revelation 3:5; 13:8; 17:8; 20:15; 21:27; 22:19.

COCK

The cock is a symbol of watchfulness, because the cock announces daybreak and alerts one to the duties of work and prayer — a resurrection after the still, quiet night. Appropriately, a cock is often used as a decoration on weathervanes and high towers. It has been associated with the apostle Peter because of Christ's prediction of Peter's denial of him: "Truly I tell you, this very night, before the cock crows, you will deny me three times" (Matt. 26:34).

CROOK, CROSIER

The crook is the shepherd's staff terminating in a curved hook at one end. They are the symbol of clerics — bishops, archbishops, abbots, and

abbesses. Each part of the crook corresponds to what they do or represent. The straight part of the crook is symbolic of righteous rule. The curved hook or head is carried so that it reaches outward to draw people to the way of Christianity. The sharp end, perfect for poking or prodding, works to rebuke the slothful.

When the staff is used as a processional symbol carried before patriarchs and archbishops, it usually terminates in a cross shape and is called a crosier. A horizontal crossbar on a crosier denotes the authority of a shepherd over his flock. The apostle Peter is depicted with a crosier, and the Pope also carries one. The single hooked form is typically used by Western bishops, whereas the bishop's staff of the Eastern Church evolved into a T-shaped scepter or one crowned by two serpents' heads.

The crosier is associated with a number of saints, including Albert the Great, Gregory the Great, James the Greater, Saint Patrick, and Saint Nicholas.

EAGLE

The eagle is a repeated motif in the visions found in Ezekiel and Revelation (Ezek. 1:4-10; 10:14; Rev. 4:6-7). Saint Jerome assigned the symbol of the eagle to John the Gospel writer "because his Gospel opens with 'in the beginning was the Word . . .' thus carrying the reader into the Heavenlies." The eagle is also a symbol of a soaring, rejuvenated spirit (Ps. 103:5) and the soul strengthened by God's grace (Isa. 40:31). It also represents divine inspiration, which is why lecterns where the Word of God is read are designed in the shape of an eagle with outstretched wings.

Tradition says that when an eagle grows old and its eyes are failing, it flies toward the sun so that the blinding film is burned away from its eyes and its feathers are renewed in the scorching heat. The eagle then dips itself in a pool of water three times and becomes young again. So believers are born into new life through baptism in the name of the Father, Son, and Holy Spirit.

KEYS

Keys are a symbol of power and authority (Isa. 22:22; Rev. 1:18; 3:7; 9:1; 20:1). They confine but also set free, since they both lock and unlock. In Christian tradition Peter holds the keys of the kingdom of heaven (Matt. 16:13-20) and is therefore portrayed with great keys. Crossed keys are part of papal heraldry, based on the tradition that Peter was given a golden key and a silver key to symbolize his dual powers to bind and loose. In depictions of the Last Judgment, a giant key is used to lock the Devil in the bottomless pit for a thousand years (Rev. 20:1-3). A key is also the way in which messages are interpreted and symbolizes decoded knowledge (Luke 12:52). A group of keys is associated with Martha, the patron saint of good housekeeping.

KNIFE

In the Old Testament, the knife is associated with Abraham, who was ready to sacrifice Isaac with a knife (Gen. 22). It became a symbol of martyrdom, most frequently associated with Saint Bartholomew, who was flayed alive with a knife. When Peter is depicted with a knife in his hand, it is a reference to his cutting off of Malchus's ear (John 18:10).

LADLE

The ladle is a symbolic attribute of Martha of Bethany, who busied herself with household tasks.

ROCK

In Scripture the rock is a symbol of God's supporting strength and security (1 Sam. 2:2; 2 Sam. 22:2-3; Pss. 18:2, 31; 27:5; 28:1; 31:2-3; 40:2; 61:2; 62:6; 71:3; 89:26; 92:15; Isa. 17:10; 1 Cor. 10:4). The rock also symbolizes Christ. The apostle Peter (in Greek, *Petros*, meaning "rock") symbolizes the solid foundation upon which the church is built (Matt. 16:18).

SAW

The saw is a symbolic attribute of Joseph the carpenter, husband of Mary. According to legend, Isaiah the prophet, Simon the Zealot, James the Less, and Jude were sawn in pieces. Thus each has the saw as his emblem.

STONES

Stones are a symbol of martyrdom, especially in depictions of Saint Stephen (Acts 7:59), Saint James the Less, Saint Matthias, and Saint Jerome.

TONGUE

In Scripture, the tongue is a reference to speech or language (Prov. 10:20; Acts 2:3-4). In Christian iconography, the tongue is associated with some martyred saints whose tongues were cut out (such as John of Nepomuk, patron saint of the Czechs).

— IV —

Glossary of Additional Symbols

Acacia Bush This bush, with leaves resembling tongues of fire, is connected to the burning bush in which the angel of God appeared to Moses (Exod. 3:2). Because the fire did not consume the bush and because of the durable nature of the wood, the acacia bush symbolizes immortality and/or permanence.

Acorn The acorn is a symbol of potential strength because it has the prospect of developing into a mighty oak.

Adder The adder represents envy and cunning. Tradition says that the adder (or serpent) envied the happiness of Adam and Even in the Garden of Eden. The adder also represents sin in the list of evil creatures conquered by Christ: "You will tread on the lion and the adder, the young lion and the serpent you will trample underfoot" (Ps. 91:13). The lion has been interpreted as the Antichrist and the adder as the Devil. In Christian iconography, the serpent has been depicted with its tail pressed to one ear and the other ear pressed to the ground so that it is unable to hear the voice of God, a posture extended to the wicked in Psalm 58:4-5.

Ant The ant is a symbol of industry and wisdom, derived from the advice in Proverbs 6:6: "Go to the ant, you lazybones; consider its ways, and be wise." The ant was said to be able to distinguish wheat, which it

ate, from barley, which it rejected, thus representing the wise person who receives the truth and rejects false doctrine.

Ape The ape symbolizes evil, sin, cunning, drunkenness, and lust. In Christian iconography, Satan appears as an ape when he tries to snare souls, sometimes shown with an owl serving as a decoy. When bound in chains, the ape represents evil conquered by good.

Apple The apple is a symbol for disobedience and original sin and, by extension, any indulgence in earthly desires and sensual pleasures. According to tradition, the forbidden fruit of the Tree of Knowledge was an apple. The idea may have originated because of a pun on the Latin *malum,* which means both "apple" and "evil." In representations of the Virgin Mary, she is often seen holding an apple by virtue of her being the new Eve through whom humankind is redeemed from the original sin of disobedience. Occasionally the Christ child is also depicted holding an apple.

Arrow The arrow is God's instrument of discipline as well as destruction of evil, enemies, and the wicked (Num. 24:8, Deut. 32:23, 42; Pss. 21:12; 38:2; 45:5; 58:7; Ezek. 5:16). The arrow has become the attribute of many saints, notably Saint Sebastian, Saint Teresa of Ávila, and Saint Augustine of Hippo.

Ass Although in some contexts the ass represents stupidity and stubbornness, the ass is primarily a symbol of humility, simplicity, and long-suffering. Jesus chose an ass to ride into Jerusalem (Zech. 9:9; Matt. 21:2, 5; John 12:14-15). The Virgin rode an ass on the way to Bethlehem; the ass was present at the Nativity (Isa. 1:3); and Mary made her flight from Egypt on the ass.

Basilisk In medieval representations the basilisk is depicted as a hybrid of a rooster and a snake, symbolizing the Devil, the Antichrist, or sin, often pictured at the feet of the victorious Christ. From the time of David, the basilisk was considered to be one of the four evil monsters — the others being the ox, the lion, and the dragon — that would be crushed by the Messiah (Ps. 91:13; Isa. 14:29).

Bear In the Old Testament, the bear is a symbol of the Kingdom of Persia (Dan. 7:5), and as such came to be associated with cruelty and evil. The bear also figures as an instrument of punishment in the passage where two she-bears mauled the children who mocked Elisha (2 Kings 2:24). According to the bestiaries, bear cubs were born and licked into shape by their mother, an image that came to symbolize Christianity converting the heathen.

Bee The bee is a symbol of diligence and industry. Since it was thought that bees never slept, they also represent vigilance.

Bird In ancient Egypt the bird was a symbol for the soul. It also has been used to represent air (one of the four elements) and the attribute of touch (one of the five senses). In allegories of the four seasons, the bird symbolizes spring. When a specific kind of bird is used in iconography, it has a special meaning.

Blood Blood is a Christian symbol of redemption and new life because of the shed blood of Christ (Eph. 1:7; Col. 1:20; Heb. 10:19; 12:24; 1 Pet. 1:2; 1 John 1:7), a sacrifice anticipated by Christ at the Last Supper (Matt. 26:28; Mark 14:24; Luke 22:20; 1 Cor. 11:25).

Bow The bow is an emblem of war, hostility, and worldly power (Jer. 49:35), as well as strength (Gen. 49:24; Job 29:20; Hos. 1:5). It is also a symbolic instrument of God's justice (Job 16:13; 20:24; Lam. 3:12; Hab. 3:9).

Bramble In Christian iconography the bramble is associated with the burning bush where God appeared to Moses (see "Acacia bush" above) and with the Virgin Mary, who bore the flames of divine love without being consumed by lust. In Scripture the bramble appears as a sign of God's displeasure, wrath, and separation (Isa. 34:13) and also as a symbol of barrenness (Judg. 9:14-15; Luke 6:44).

Bull The bull, an object of worship in primitive religions, is associated with strength and fertility. In the Old Testament, the bull was the symbol of the god Baal, denounced by the prophets.

Bulrush The bulrush as a symbol of salvation is derived from the Old Testament story of Moses' rescue by Pharaoh's daughter (Exod. 2:3).

Cat The cat is one of the animal forms assumed by the Devil. Just as a cat catches mice, so the Devil tries to capture souls. In Mediterranean lore, Isis, a goddess of the underworld, was accompanied by a black cat. Thus black cats became associated with the Devil and witches in Christian art.

Cloak, Robe While nakedness symbolizes innocence and freedom from worldly adulteration, being covered with a cloak or robe has a wide range of meanings. Fine robes can connote privilege and authority; they can also represent foolishness and pride. In addition, the cloak can stand for secrecy and magic powers. In the book of Revelation white robes are used metaphorically as a sign of purity and holiness (4:4; 7:9; 15:6; 19:13-14).

Cockle The cockle is a weed that grows up among cultivated plants, symbolizing the evil which infiltrates the good (Job 31:40).

Coral Coral was first used for decorative purposes by the Romans. In the Middle Ages it was known for its healing properties and its power to avert the curse of the "evil eye." In medieval and Renaissance paintings of Mary and the Christ child, the coral — usually a string of beads — in the hand of the infant Jesus signifies protection from the Devil. It is included in the biblical lists of things of great value (Job 28:18; Ezek. 27:16).

Cornucopia The cornucopia, or "horn of plenty," is a symbol of abundant blessing and fruitfulness that has its origins in early Greek mythology. The earliest associations began with the belief that power and fertility resided in the horns of goats and bulls.

Curtain The curtain is a symbol of separation. In the Temple in Jerusalem, a curtain separated the Holy of Holies from the Holy Place. When Jesus died, the curtain was torn in two (Luke 23:44-46).

Dandelion The dandelion is a bitter herb used as a symbol of the Passion in early Flemish and German paintings of the Crucifixion. It also

symbolizes grief because it is assumed to be the herb that the Israelites ate on the night of the Passover (Exod. 12:8).

Darkness Darkness has a range of meanings. In Genesis it is a symbol of primeval chaos (1:2). In addition, it can represent evil: Satan is associated with the powers of darkness (Eph. 6:11-12; Col. 1:13). Physical darkness is also a metaphor for spiritual darkness (2 Sam. 22:29; Isa. 9:2), demonstrated by nature at the Crucifixion (Mark 15:33; Luke 23:44). Darkness is also used as a metaphor for spiritual blindness and separation from God (Ps. 107:10-11, 14; John 1:5; 3:19-20; Acts 26:18; Rom. 2:19; 2 Cor. 6:14; Eph. 5:8; 1 Thess. 5:4-5; 1 Pet. 2:9; 2 Pet. 2:4; 1 John 1:5-6; 2:8-9; Rev. 16:10). Darkness can refer to a state of ignorance (Eccles. 2:14) or to a place or condition of judgment (Prov. 20:20; Isa. 8:22; 13:10; Jer. 4:28; Ezek. 32:7-8; Joel 2:2, 10; Amos 5:18, 20; 8:9; Matt. 24:29; Mark 13:24; Luke 23:45; Rev. 8:12; 9:2). Interestingly, the mysterious side of God is referred to as darkness (Exod. 19:16; 2 Sam. 22:10-12; 1 Kings 8:12; 2 Chron. 6:1; Pss. 18:11; 97:2; Heb. 12:18).

Dawn Dawn is a poetic reference to rebirth, regeneration, new life, hope, salvation, and eternal life (Ps. 139:9; 2 Pet. 1:19).

Dew In Scripture, dew and rain symbolize blessings (Gen. 27:28), and dew is believed to fall from the heavens to raise the dead (Isa. 26:19). In the Middle Ages, dew was interpreted as a sign of Christ's coming (Isa. 45:8). It also symbolizes the gift of the Holy Spirit, which revitalizes the soul.

Diamond The diamond is associated with permanence (Jer. 17:1) and incorruptibility; in early Christian texts it symbolizes Christ. It also symbolizes the sun and light.

Dog The dog is a symbol of fidelity and consequently is placed at the feet of women on medieval tombs or in marriage portraits. In old German art, three dogs represent Mercy, Truth, and Justice. Because it frequently serves as guard, the dog became the emblem of priests, who are appointed to be caretakers of the Shepherd's flock. It is interesting to note that in much of Scripture, dogs are not viewed favorably. In some contexts, "dog" is a contemptuous epithet (Phil. 3:2; Rev. 22:15).

107

Dragon In Christian tradition, the dragon is a symbol of Satan or any enemy of God (Isa. 27:1; 51:9; Ezek. 29:3; 32:2; Rev. 12:9; 20:2). It also represents evil more generally (Num. 21:6; Eccles. 10:11; Isa. 51:9). A dragon chained or trodden underfoot symbolizes the conquest of evil (Ps. 91:13; Rev. 20:1-2). There are many legends of the slaying of the dragon by various saints such as Saint George, Saint Andrew, Saint Martha, and the archangel Michael (Rev. 12:7-9).

Ear Because the Word of God (*Logos*) enters the mind by way of the ear, and because the Psalmist said, "Daughter . . . incline your ear" (45:10), tradition says that the Virgin Mary conceived Christ through her ear. That is why, in scenes depicting the Annunciation, a ray of light descends toward Mary's ear. In Scripture, the ear of God is inclined to hear the needs and prayers of the faithful (Pss. 17:6; 39:12; 77:1; 80:1; 84:8; Neh. 1:6; 1 Pet. 3:12). The ear is also a symbol of the betrayal of Jesus, based on the incident in which Peter cut off the ear of Malchus, the slave of one of the men who came to arrest Jesus (Luke 22:50; John 18:10).

Ermine The ermine is a symbol of purity because legend has it that the ermine would rather be captured than get dirty ("better death than dishonor"). Because it was believed that the ermine was conceived through the ear, the ermine is associated with the Incarnation of Christ. See "Ear" above.

Falcon Two types of falcons are used in Christian symbolism: the wild and the domestic. The wild falcon represents the evil, unregenerate person, while the domesticated falcon represents the holy, regenerate person.

Fig Tree, Fig Leaf The Tree of Knowledge in the Garden of Eden (Gen. 3:7) is sometimes thought to be a fig tree rather than an apple tree. In Gnostic and Islamic traditions, the two forbidden trees in the Garden were the olive tree and the fig tree. (When Adam and Eve ate the "forbidden fruit," they became aware of their nakedness and sewed fig leaves together to cover themselves; thus the fig leaf is a symbol of lust and shame.) The fig tree can be a symbol of fertility because of the many seeds that figs contain. Similarly, it is a symbol of spiritual fruit-

fulness and good works (Jer. 24; Matt. 7:16). In Christ's only miracle of judgment, he cursed the barren fig tree (Matt. 21:18-22) and later declared the fig tree to be a sign of the times (Matt. 24:29-36).

Flowering Rod The flowering rod is a reference to Aaron's rod, which blossomed and produced ripe almonds when placed before the Ark of the Covenant (Num. 17:8). When Joseph, the chosen husband of the Virgin Mary, placed his rod on the high priest's altar, it flowered (according to the apocryphal book of James).

Fly The fly is a creature with negative symbolic associations — the bearer of bad news, evil, and pestilence (Exod. 8:21; Pss. 78:45; 105:31; Eccles. 10:1; Isa. 7:18). Baal-zebub ("lord of the flies"), the god of Ekron, referred to in 2 Kings 1:2, was a Syrian divinity associated with the control of swarming flies. In the mid-fifteenth century, religious paintings included representations of a life-size fly. This depiction served as a talisman against the real insect, which might leave marks on the painting.

Fortress The fortress is an Old Testament metaphor for security and protection (2 Sam. 22:2; Pss. 31:2-3; 59:9; 91:2; 144:2; Prov. 10:15; Dan. 11:38).

Fox The fox, a symbol of astuteness and trickery, became a symbol for the Devil during the Middle Ages. Christ calls Herod a fox (Luke 13:32).

Frankincense Frankincense is a sweet-smelling resin obtained from African and Asian trees. It symbolizes divinity and thus was an appropriate gift offered by one of the three kings to the Christ child (Isa. 60:6; Matt. 2:11). According to Saint John Chrysostom (one of the four Greek fathers of the church), gold, frankincense, and myrrh symbolize truth, obedience, and love.

Frog The frog is primarily a symbol of evil because of its association with the plagues of Egypt (Exod. 8:2-14) and because of the negative reference to it in Revelation (16:13). Because of the frog's muddy habitation and loud croaking, early church leaders compared it to the Devil or heretics who promote false doctrine. The frog was a positive symbol in Coptic Egypt: it represented resurrection and rebirth because of its

remarkable ability to sustain itself through winter and emerge in the spring.

Fruit A basket or cluster of fruit symbolizes the fruits of the Holy Spirit — love, joy, peace, patience, kindness, generosity, faithfulness, gentleness, and self-control (Gal. 5:22-23). Fruit is used poetically to refer to godly deeds (Ps. 1:3; Matt. 3:8-10) and is a sign of one's inner character (Ps. 92:12-15; Prov. 11:30; Matt. 7:16; John 4:36; Rom. 7:4; Col. 1:10; James 3:17). Fruit also represents God's blessings and provisions (Ps. 128:2; Jer. 2:7).

Garden The garden is a symbol of nature controlled and subdued, in contrast to the wild, uncontrolled forest. It symbolizes humankind's innocence in Eden (Gen. 2:8) before the Fall. In depictions of the Annunciation, the enclosed garden is a reference to the virginity of Mary.

Goat/Scapegoat The goat is primarily a symbol of sacrifice, a prophetic figure of the Redeemer in the Old Testament. In Numbers 29, ten different occasions are given for the sacrifice of a goat before Yahweh — all for the remission of sins. In Leviticus 16, two goats are required as a sin offering: one is sacrificed, and the other, the scapegoat, is sent into the wilderness, bearing all the sins of the people (16:5, 15-22). In Christian symbolism, Christ is both the scapegoat and the other goat that is sacrificed to God the Father as a ransom for the world.

In the book of Matthew, Christ uses the goat as a symbol of the accursed when he judges and separates the sheep from the goats (Matt. 25:31-34, 41; cf. Ezek. 34:17). The he-goat is also the emblem of the King of Hell. Medieval demonologists show Satan in the guise of a buck goat that presides over devils' sabbaths.

Hair In Old Testament times, hair was a sign of vitality, energy, and fertility (Judg. 16:17); it relates to the Nazarite vow illustrated in the story of Samson. The Israelite custom was to grow hair long; admiration for Absalom's luxuriant hair is recorded in 2 Samuel 14:26. By the time of the New Testament, long hair was a shame to a man (1 Cor. 11:14), though women still wore their hair long (1 Cor. 11:15).

To leave hair unkempt was a sign of fear and distress and grief. Hair was anointed for festive occasions (Ps. 45:7); a guest in one's house was

welcomed by the ritual of anointing (Luke 7:46). God's care is illustrated through the reference Christ made to his knowing the number of individual hairs on our heads (Matt. 10:30; Luke 12:7).

Hand The hand has multiple meanings. Like the arm, the hand is used as a symbol of might and power (Ps. 31:15; Mark 14:41). The dropping of hands indicates weakness or lack of resolve (Isa. 13:7), whereas the lifting up of hands is a gesture of praise or supplication (Exod. 9:33; 17:11; Job 11:13; Ps. 28:2; 1 Tim. 2:8). Two people clasping hands is symbolic of an agreement (Job 17:3). Raising the right hand in a court of law is an early sign of taking an oath (Gen. 14:22; Exod. 17:16), and sitting at the right hand is sitting in the place of favor (Ps. 45:9). The laying on of hands is a symbol of blessing, power, and the communication of authority and benediction (Gen. 48:13-14; Lev. 1:4; 9:22; Num. 8:10-11; 27:18-23; Deut. 34:9; Matt. 19:13; 10:16; Luke 24:50; Acts 8:17-19; 19:11; 1 Tim. 4:14; 2 Tim. 1:6). The laying on of hands is also a gesture of healing (Mark 6:5; 7:32; 16:18; Luke 4:40; Acts 28:8). The ceremonial washing of hands is a symbol of cleansing (Matt. 15:2; Mark 7:2-5). Clapping hands is a sign of joy (2 Kings 11:12; Ps. 47:1).

Hare Because of its readiness to mate, the hare has been a symbol of lust and fertility. The white hare portrayed at the feet of the Virgin Mary is a symbol of triumph over the desires of the flesh.

Harp/Lyre The harp or lyre is a symbol of music that brings glory to God in worship (1 Sam. 16:15-23; 1 Chron. 13:8; Pss. 33:2; 137:2; Amos 6:5; Rev. 5:8; 14:2). In architectural mosaics the lyre is adorned with the six-pointed Star of David, a symbol of the Jewish faith and the state of Israel.

Heart The heart is a symbol of love and devotion. According to Scripture, the heart is the inner person, the moral and spiritual center (1 Sam. 16:7; 1 Kings 15:3; Job 29:13; Pss. 4:7; 15:2; 27:3; 111:1; 119:11; Prov. 17:22; 23:26; 25:20; Jer. 11:20; 17:9; Ezek. 44:7; Joel 2:13; Matt. 5:28; 11:29; 12:34; 15:8; Mark 12:30; Luke 2:19, 51; Acts 2:37; 2 Cor. 3:3; 5:12). In Roman Catholic devotional art, when the heart appears in flames, it stands for ardor. A heart pierced with three nails and encircled by a crown of thorns is called the "sacred heart." During the seven-

teenth century this depiction was widely venerated. The heart pierced by a spear is a Passion symbol. When combined with a cross and an anchor, it stands for Charity in the Three Graces — Faith, Hope, and Charity.

Honey Honey is a symbol of provision, abundance, and blessing (Exod. 3:8; Lev. 20:24; Deut. 8:8; 32:13; Ps. 81:16; Ezek. 20:6). The sweetness of honey describes the sweetness of God's words (Ps. 119:103; Ezek. 3:3; Rev. 10:9).

Horns Many primitive traditions, including the tradition of the Israelites, associate horns with strength and power (2 Sam. 22:3; 1 Kings 22:11; Jer. 48:25; Dan. 7:15-28; Hab. 3:4; Zech. 1:18-21). The horn is both a symbol of divine strength (Luke 1:69; Rev. 5:6) and a symbol of the satanic dragon's infernal powers (Rev. 12:3). Other apocalyptic uses of the horn are found in Daniel 7 and 8 and Revelation 13 and 17.

The horn was used as a receptacle for anointing oil (1 Sam. 16:1, 13; 1 Kings 1:39) and as a musical instrument. There were four horns on the corners of the altars in the tabernacle and the Temple (Exod. 29:12; Lev. 4:7, 18; 1 Kings 1:50; 2:28).

Horse The horse is an embodiment of vitality and power (Job 39:19-25). In medieval imagery the horse usually has a rider, the two forming one symbol, typically representing Jesus Christ incarnate. The horse represents his humanity, the rider his divinity. Almost all sacred or miraculous horses are white. The four horses of different colors in Revelation are divine instruments of judgment on the enemies of God's people. The colors may represent geographical points of the compass (Rev. 6:1-17; 19:11-16; cf. Zech. 6:1-8). Of the four horses and riders appearing in this vision, Christian symbolism has kept only the first, the white horse and rider, as the image of the victorious Christ.

Hourglass The hourglass is a symbol of the transitory nature of life. The hourglass is one of the objects in *vanitas* (Latin for "emptiness" or "vanity"), still-life paintings that usually include a skull (a reminder of death), an hourglass or candle (alluding to the passing of time), an overturned vessel (representing emptiness), a crown, jewels, a purse, or coins (symbolizing the power and possessions of this world lost in

death), a sword or other weapon (a reminder that there is no protection against death), and flowers with dewdrops (indicating the shortness of life and the inevitability of decay).

Hyena The hyena's main role in Christian iconography is to symbolize avarice (Jer. 12:9). The hyena, which eats decaying corpses, has also been used as a symbol of the person who thrives on false doctrine.

Iconostasis In Orthodox churches, the iconostasis (from the Greek word meaning "image screen") is a screen or wall with an arrangement of icons. It divides the main body of the church from the sanctuary, but it is considered a link, not a barrier. It symbolizes the integration of earthly worshippers with the whole company of heaven. Beyond the screen is the Holy of Holies, where the sacred elements are consecrated. (See "Royal Doors" below.)

Jewels Jewels often signify knowledge and spiritual truth (Prov. 20:15). Sometimes wisdom is said to be "better than jewels" (Prov. 8:11).

Jordan River Crossing over the Jordan River is a metaphor for going to heaven. It refers to the Israelites crossing the river on their way to the Promised Land (Josh. 3:7-17). This was also the place where Christ was baptized by John (Matt. 3:6, 13; John 3:26), and therefore it has symbolic connections to the Christian rite of baptism.

Knot In the Romanesque period, braided ornamentation symbolized the knots of destiny, which are tied by divine power. In Anglo-Saxon art, this power was Christ's alone, and he was depicted freeing humanity from its bonds.

The knot is also a symbol of union and promise. Two knots woven together commemorate marriage. Some orders of monks wear corded belts with three knots to remind them of their three vows of poverty, chastity, and obedience.

Lamp/Lantern The lamp or lantern is a symbol of guidance and knowledge (Ps. 119:105 — guidance by God's word); wisdom (Matt. 25:1-13 — the wise and foolish virgins); and good works (Matt. 5:15-16 —

letting the light of one's good works shine). The lamp that burns as a "perpetual ordinance" in front of the curtain of the Holy of Holies in the tabernacle is designated in Exodus 27:20-21 as a symbol of the ever-present Jehovah.

Leaven/Yeast Leaven is anything added to dough that makes it ferment, such as yeast. Early Jews were prohibited from using leaven during Passover and the feast of unleavened bread (Exod. 23:15, 18; 34:18, 25). In fact, there were only two offerings in which they were permitted to use leaven (Lev. 7:13; Amos 4:5).

In the New Testament, leaven and yeast were sometimes used as symbols of sin and that which corrupts (Matt. 16:6; 22:16-22; 23:14; Mark 3:6; 8:15; Luke 12:1; 1 Cor. 5:6; Gal. 5:9). Their function implied corruption and disintegration — a decayed state. Christ contradicted this view of leaven when he likened the kingdom of heaven "to yeast that a woman took and mixed in with three measures of flour until all of it was leavened" — a reference to the mysterious, all-transforming power of the kingdom (Matt. 13:33; Luke 13:21).

Leopard Some have connected the leopard with the Antichrist and the descriptions of the beast in John's vision in Revelation (13:2). By association, the leopard is a symbol of sin and the great destroyer, Satan. According to popular belief, too, the leopard changed its spots to deceive. This led early iconographers to use the leopard as one of the principal images of Satan.

Early Christian symbolism drew on an old misconception that the leopard was born of a lion and a panther (the Greek *leon* plus the Greek *pardusrr*). Consequently, the leopard came to represent illegitimate offspring.

Leviathan Leviathan, a sea monster, is most often equated with hell and the grave because of the three days and nights that Jonah spent in the belly of a great fish, which Jonah refers to as "the belly of Sheol" (Jon. 1:17; 2:2; Matt. 12:40). Leviathan is also a symbol of Satan (Job 41; Isa. 27:1).

Lily of the Valley Lily of the valley is occasionally a symbol of the Virgin and the Immaculate Conception because of its white purity and

sweet scent. Also as one of the first flowers of spring, it became a symbol of the Resurrection.

Lizard The lizard is a symbol of the transforming power of the Gospel, which is able to give spiritual sight. This reference is based on the alleged ability of an old lizard to regain its sight by slipping into a crack in a wall that faces eastward and looking into the rising sun. Because the lizard also sheds its skin, it became a symbol of resurrection and renewal.

Locust Locusts are a symbol of destruction (Exod. 10:4; Ps. 105:34; Rev. 9:1-10). For the prophet Joel, a plague of locusts is the essence of divine retribution (1:4). The locust also became the image of the heretic or anyone who sows discord.

Lynx The lynx is a symbol of vigilance because it is an animal noted for amazingly keen eyesight. In medieval iconography, perhaps because of its rusty red coat, the lynx is relegated to the realm of the Devil.

Lyre See "Harp/Lyre" above.

Mallow/Hollyhock The mallow or hollyhock is a tall plant used for medicinal purposes. The leaves of the mallow, which resemble palms turned upward, were considered to be a plea for forgiveness. In Christian art, the mallow is used to symbolize prayer for forgiveness.

Maniple A maniple is a long strip of silk worn over the left arm by the priest at Mass. It is a reference to the cord used to bind Jesus at his arrest. The maniple is also considered a symbol of spirituality and purification.

Marguerite The marguerite, also called the meadow daisy, is a chrysanthemum with a white, tear-shaped blossom. In paintings of the medieval period, it appears as a symbol of the death and suffering of Christ and martyrs.

Moon Origen (185-254) saw the moon as a symbol of the church, which receives illumination and then transmits it to all believers. The

moon is also a sign of the Resurrection, since it is reborn every month. In Christian iconography, the moon is usually depicted as a crescent moon, an attribute of the Virgin Mary; it appears under the Virgin's feet in scenes of the Assumption (Rev. 12:1).

The moon with the sun is a symbol of permanence (Pss. 72:5; 136:9). The sun and moon are also used in paintings of the Crucifixion to show the convulsions of sorrow in the heavenly bodies.

Myrtle In Christian symbolism, the myrtle, a fragrant evergreen, is an allusion to the Gentiles who were converted to Christ (Zech. 1:7-11). The myrtle trees were interpreted as being the army of the saints who would bear witness to the faith.

Oil Oil is a symbol of divine blessing. Anointing with oil is used metaphorically to indicate the bestowal of divine favor (Pss. 23:5; 92:10), the appointment to a special function for God's purposes (Ps. 105:15; Isa. 45:1), and the equipment for service by the Spirit of God (1 Sam. 10:1; 16:13; Isa. 61:1; Zech. 4:1-14; Acts 10:38; 1 John 2:20, 27). In the Old Testament, persons and things were anointed with oil to signify holiness or ordination or consecration unto God (Gen. 28:18; Exod. 28:41; 30:22-38; 2 Sam. 2:4; 1 Kings 1:34; 19:16). (Significantly, the meaning of *Messiah* in Hebrew is "Anointed One.") Anointing with oil continues to be used in baptism, confirmation, ordination, and healing (James 5:14).

Olive Branch An olive branch is a sign of peace and is occasionally shown in the hand of the Archangel Gabriel as a sign of the coming of the Prince of Peace.

Orange/Orange Tree The orange or orange tree most frequently represents chastity and purity because of the tree's white blossoms. It is often used to symbolize the purity of the Virgin Mary. However, in Christian iconography, when an orange tree appears in the Garden of Eden, it, like the apple tree, stands for the fall of humankind.

Oven/Furnace In the Old Testament, the oven or furnace is an image of trials and tribulations (Deut. 4:20; 1 Kings 8:51; Jer. 11:4). Those

pleasing in God's sight withstand the flames of the furnace (Dan. 3:19-30).

Owl The owl, a nocturnal bird, is a symbol of night and sleep. In the Old Testament, it is listed among the unclean animals (Lev. 11:16-17; Deut. 14:15-16), and in Christian symbolism, it represents spiritual darkness.

Despite these negative connotations, the owl was a sign of meditation in medieval monasteries because it was known to stay in the same place in a tree all day long. In the twelfth century, Eustathius, archbishop of Thessalonica, expressed the view that the owl's clear vision at night was due to its powerful eyes, which could dissolve the shadows. This corresponds to Christ, who is all-seeing — and who is also the Light of the World.

Palm The palm began as a symbol of pagan victory, as can be seen from the design of some classical triumphal arches. But this motif was also used by Solomon in the temple he built (1 Kings 6:29, 32, 35). In the Christian era it became a symbol of the victory of faith over the suffering of martyrdom. It is closely tied to the entry of Christ into Jerusalem on Palm Sunday.

Path The path is an ancient symbol of life's pilgrimage (Pss. 17:5; 119:35, 105; Prov. 4:18; 15:24; Isa. 42:16; 45:13). Scripture gives particular significance to the motif of two paths — the way of the righteous and the way of the ungodly (Ps. 1; Ps. 139). The letter Y is a symbol of the forked path, which emphasizes choice.

Pearl In his teaching, Christ used references to the pearl in two different ways. The "pearl of great value" refers to the kingdom of heaven (Matt. 13:45-46). And the caution not to throw "pearls before swine" refers to safeguarding what is holy — the word of God (Matt. 7:6).

Peony In medieval paintings the peony, a rose without a thorn, is a symbol of Mary.

Quince Quince is a fruit shaped like an apple, the forbidden fruit, thus symbolizing sin and temptation.

Rain Most cultures interpret rain as a symbol of heavenly workings on earth. In Scripture rain is a sign of God's providential care (Deut. 11:13-14; Job 37:6-7; Isa. 30:23; Jer. 5:24; 14:22; Hos. 6:3; Mic. 5:7).

Rainbow Originally the rainbow was the sign of God's promise that the earth would never again be destroyed by flood (Gen. 9:8-17). In medieval depictions of Christ as ruler, he is seated on a rainbow, a reference to this covenant with humankind. In many cultures the rainbow is a manifestation of divine benevolence.

Raven In Christian tradition the raven has been associated with Satan and sin because it is an "unclean" bird of prey, although it has also been associated with solitude because it prefers to live apart from the flock. Another positive association comes from the story of Elijah. When he fled from Ahab to the brook Cherith, ravens fed him, a reminder of God's providence and of hope (1 Kings 17:1-6).

Right, Right Hand In many cultures, the right is regarded as the better side. In Scripture it is the side of strength, security, and salvation (Job 40:14; Pss. 16:8; 17:7; 18:35; 20:6; 60:5; 63:8; 73:23; 77:10; 98:1; 110:1, 5; 118:15-16; 138:7; 139:10). The seat on the right hand of God or an important personage is regarded as a preferred place of honor (Mark 16:19; Acts 2:33; 7:55; Eph. 1:20; Col. 3:1; Heb. 1:3; 8:1; 10:12; 12:2; 1 Pet. 3:22). And the right hand is used for blessing (Gen. 48:17-18; Ps. 16:11; Rev. 1:17).

This biblical emphasis is reflected in Christian art. In the icons of Christ as Pantocrator (Ruler), his right hand is raised in the gesture of blessing. In scenes depicting the Last Judgment, the chosen stand at the right side of Christ, the damned at his left. In depictions of the Crucifixion, the repentant thief is on Christ's right side.

Robes Fine robes connote privilege and authority (Luke 15:22; John 19:5; Rev. 6:11). They have salvific meaning in Isaiah 61:10: "My whole being shall exult in my God; for he has clothed me with the garments of salvation, he has covered me with the robe of righteousness."

Rod, Staff The rod or staff is a symbol of authority (Gen. 49:10; Exod.

4:20; Num. 17; Judg. 5:14; Jer. 48:17; Heb. 9:4), as well as of divine protection and guidance (Ps. 23:4).

Royal Doors In Eastern Orthodox churches, the royal doors are made of two panels located at the center of the iconostasis (the screen or wall that separates the sanctuary and the nave) and serve as the connection between the nave and the sanctuary. They are called "royal" because Jesus Christ the King is carried through them in the form of the Eucharist (Ps. 24:7).

Ruins In later medieval art, the motif of a ruined building represented the Old Dispensation (Judaism) and served as a contextual backdrop for scenes of the Nativity of Christ and the Adoration of the Magi. Later, in Italian Renaissance paintings, ruins are classical in style and symbolize the decay of the pagan world.

Sackcloth Sackcloth was a coarse cloth made from goats' hair, dark in color (Rev. 6:12). It was worn as a sign of grief (Gen. 37:34; 2 Sam. 3:31; Esther 4:1; Job 16:15; Lam. 2:10; Joel 1:8), as a sign of penitence for sins (1 Kings 21:27; Neh. 9:1; Jon. 3:5; Matt. 11:21), or as a sign of special petition for deliverance (2 Kings 19:1-2; Dan. 9:3). Often the penitents also covered themselves with ashes to complete the symbolism. In Isaiah 50:3 a reference to sackcloth is used to indicate God's rebuke of his people: "I clothe the heavens with blackness, and make sackcloth their covering."

Sacrament A sacrament is an outward symbol or sign, from the Latin *sacramentum,* meaning "sacred obligation," a divinely instituted rite signifying and conferring grace. Roman Catholics and Orthodox Christians recognize seven: Baptism, the Lord's Supper (Eucharist), Confirmation, Confession (Penance), Holy Orders (for clergy), Matrimony, and Extreme Unction. Protestant churches recognize Baptism and the Lord's Supper. The depictions of the sacraments flourished in the art of the Counter-Reformation, a reaction to the Reformation's denial of the sacramental validity of penance and the Protestants' rejection of transubstantiation.

Salt In biblical times, salt was used in ceremonies ratifying agreements

and as such served as a symbol of fidelity and constancy. In the Levitical cereal offerings, its function as a preservative symbolized the eternal nature of the covenant existing between God and Israel (Lev. 2:13; Num. 18:19; 2 Chron. 13:5). Christ referred to his disciples as "the salt of the earth" (Matt. 5:13; Mark 9:50; Luke 14:34-35) and as "the light of the world" (Matt. 5:14). Both are references to believers' witness and influence.

Sanctuary The Hebrew word for sanctuary simply means a place set apart for the worship of God. The Israelites' earliest sanctuary was the tent known as the tabernacle, where the Ark of the Covenant was housed (Exod. 25:8-40). The temple, Israel's permanent place of worship, was designed by David and built by Solomon (1 Chron. 22:19; 28:10-21). In the New Testament the sanctuary is the dwelling place of God, whether literal (Mark 14:58; 15:38; John 2:19) or figurative (1 Cor. 3:16-17; 6:19).

In modern churches the sanctuary is the east end of the church building, the apse. It contains the altar that symbolizes Christ's tomb, signifying rebirth (the eastward direction indicating the dawn of a new day). In the Orthodox Church, the sanctuary is separated from the nave by the iconostasis. In the Roman Catholic Church, screens or rails are used.

Sand Grains of sand and innumerable stars are biblical hyperbolic symbols of uncountable numbers or infinity (Gen. 22:17; 32:12; Isa. 10:22; Hos. 1:10; Rom. 9:27; Heb. 11:12).

Scales Scales are a symbol of justice and judgment, used for weighing good and evil, right and wrong (Prov. 16:11; Dan. 5:27). Michael the Archangel is depicted as the angel who weighs souls, especially in scenes of the Last Judgment. In Revelation, one of the four horsemen of the Apocalypse holds a pair of scales (6:5). A sword and scales have been the symbol of justice since the days of Rome.

Scarlet Woman "Scarlet Woman" is the common name for the Great Whore of Babylon, dressed in scarlet and "drunk with the blood of the saints" (Rev. 17:3-6) — an archetypal image of idolatrous worship.

Scepter The scepter is a sign of royal power (Gen. 49:10; Num. 24:17; Ps. 45:6). In Christian iconography, canonized rulers often hold a scepter.

Screen The screen is a partition that divides the sanctuary or chancel from the nave of the church. It serves as a symbolic separation of the holy from the profane. See "Iconostasis" above.

Scythe/Sickle The scythe or sickle has been a symbol of time and death since the Renaissance. Often a skeleton is pictured holding a scythe — the "Grim Reaper." Occasionally, in depictions of the Apocalypse, the enthroned Christ and his angels hold sickles, anticipating the harvest of the earth, a time of final judgment (Rev. 14:14-20).

Seal In ancient times the seal symbolized legitimacy and authority. Metaphorically, the seal stood for what it secured (Deut. 32:34; Job 14:17). Often in Scripture it refers to our belonging to God (John 6:27; Rom. 4:11; 2 Cor. 1:22; Eph. 1:13; 4:30; Rev. 7:3; 9:4). God's mysteries are also sealed (Rev. 5:1-5).

Serpent The serpent stands for the Devil or for sin and evil, based on the serpent's tempting of Eve in the Garden (Gen. 3:1-6; 2 Cor. 11:3). In Christian art of the Middle Ages, the seductive aspect of the serpent is commonly accentuated. In these depictions, the serpent is part snake and part woman (given a woman's head and chest). When placed at the feet of the Virgin Mary, the serpent is a symbol of the defeat of sin through the Incarnation. A serpent on a cross signifies Christ (Num. 21:8; John 3:14 — see "Serpent on Cross" above).

Shadow A shadow can symbolize the fleetingness of life (1 Chron. 29:15; Job 14:2; 17:7). A shadow can also be a place of shelter and relief (Ps. 91:1; Isa. 25:4; Lam. 4:20: Ezek. 31:6; Jon. 4:5-6). Old Testament rituals are called shadows of good things to come (Col. 2:17; Heb. 10:1). God's unchangeable character is contrasted with the passing shadows (James 1:17).

Sibyl Sibyls are the twelve female Greek and Roman counterparts of the Old Testament Prophets. These priestesses of Apollo prophesied

the coming of Christ in the Sibylline Oracies. The two best-known Sibyls were Tiburtine, who told Augustus of the future birth of an emperor even mightier than he, and Erythrean, who is supposed to have foretold the Annunciation. In Renaissance art, the twelve Sibyls are identified by the symbols related to their prophecies. Their names come from geographical associations: Persica, Libyca, Erythrai, Samia, Europa, Cimmeria, Tiburtina, Agrippa, Delphica, Hellespontica, Cuman, and Phrygia. The most famous depiction of the Sibyls is Michelangelo's rendering of them on the ceiling in the Sistine Chapel.

Siren In Greek mythology, sirens were females that were part human and part bird or part fish, able to sing bewitchingly. With their songs they had the power to confuse men's senses, lull them to sleep, and then destroy them. Satan as the serpent is sometimes depicted with the face of a beautiful woman, based on the legend that a siren tempted Eve to eat the forbidden fruit. In the Middle Ages, sirens were often portrayed as symbols of worldly and devilish enticement.

Skeleton The skeleton is a symbol of death often depicted with a scythe and an hourglass. (See "Scythe/Sickle" above.) In Christian iconography, skeletons emerge from tombs and from the earth at the Last Judgment.

Skull The skull as a symbol of death has medieval origins. In the art of the West, it is a symbol of impermanence. In the sixteenth century, saints were depicted at prayer, gazing at a skull. This subject, together with *vanitas* pictures (see "Hourglass" above), was symbolic of the transience of life on earth. In paintings of the Crucifixion, a skull at the base of the cross represents Adam's skull (1 Cor. 15:22).

The skull is a common image in funerary sculpture. In Puritan gravestone carving, winged skulls symbolize released spirits.

Snail The snail is a resurrection symbol because in the fall it seals itself inside its shell with a lid-like structure that it later opens so that it can re-emerge after winter.

Snow In Scripture, the whiteness of snow represents moral purity (2 Kings 5:27; Ps. 51:7; Isa. 1:18; Lam. 4:7; Dan. 7:9; Matt. 28:3; Mark

9:3; Rev. 1:14). Because of its pure whiteness, snow is a symbol of the Virgin Mary.

Sparrow In Scripture we are told that God watches over even the lowly sparrow, so he will certainly watch over us (Matt. 10:29-31; Luke 12:6-7).

Spider The spider is primarily a symbol of Satan. As a spider traps with its web, so the Devil traps with temptation. The fragile construction of the spider's web is compared to the vain hope of the godless (Job 8:14).

Staff See "Rod, Staff" above.

Storm The storm is a symbol of the power and judgment of God (Jer. 23:19; Jon. 1:12) as well as a metaphor for trouble (Ps. 107:23-29).

Swan In medieval bestiaries the swan is a symbol of the hypocrite. Christians believed that the bird covered its black, sinful flesh with white garments. When the bird's white plumage was stripped away, its black flesh was roasted in the fire. So, too, the hypocrite would be judged and punished.

Sword The sword is primarily a symbol of the martial virtues of strength and courage. Negatively, it is a symbol of war (Gen. 27:40) and judgment (Gen. 3:24; Num. 31:8; Deut. 32:41; Ps. 17:13; Hos. 11:6; Zech. 13:7; Rev. 1:16; 2:12; and Rev. 2:16, where it is the sword of Christ's mouth). The sword also represents the malicious tongue in its destructiveness (Ps. 57:4; Prov. 25:18). In the West, the sword is the weapon of the Archangel Michael, King David, Judith, Paul, Saint George, Joan of Arc, and numerous others who were martyred by the sword.

Tabernacle The tabernacle is the portable sanctuary, the "tent of meeting," which served as the special dwelling-place of God that the Israelites carried with them in their wilderness journeys (Exod. 25:8-9; 26:33, 36). Theologically, the tabernacle, as a dwelling place of God on earth (Ps. 90:1), is the first in a series of symbols: God also dwelt in the Temple (2 Kings 11:10; 1 Chron. 29:2-3) and in the incarnated Christ

(John 1:14; John 2:19; Col. 1:15, 19; 2:9); and he dwells in the individual believer (1 Cor. 3:16; 6:19) and the church (2 Cor. 6:16; Eph. 2:19-22). The tabernacle is a symbol of God's dwelling place (Ps. 15:1; Heb. 8:2, 5; 9:1-12, 24). In Roman Catholic liturgical usage, the tabernacle is a receptacle in which the Reserved Sacrament for the communion of the sick and dying is kept. After the Council of Trent, it became obligatory to place the tabernacle in the center of the altar in Roman Catholic churches.

Table In religious art, the table is most frequently identified with the drama of the Last Supper and Christ at Emmaus. In medieval Christian tradition, a circular table represents the universe. (See "Circle, Sphere, Ring" above.) The Holy Grail, the legendary chalice used by Christ at the Last Supper (later a receptacle for his blood), sits in the center of the table as the key to salvation for the universe. In modern times the table serves as the symbolic gathering-place for the Christian community's participation in the sacred meal — the Eucharist, the love feast that anticipates the marriage supper of the Lamb (Matt. 26:26-29; Rev. 19:9).

Tablets of the Law The Tablets of the Law are symbols of the Old Covenant. Two flat tablets of stone with arched tops are common visual representations of the Ten Commandments (Exod. 31:18; 34:1; Deut. 5:22; 10:1).

Temple The English word *temple* derives from the Latin word *templum,* akin to the Greek word *temenos,* meaning "sacred precinct," a space for worship sealed off from the secular world. Figuratively, the temple is used to represent the body of Christ (Matt. 26:61; 27:40; John 2:19), believers in whom the Holy Spirit indwells (1 Cor. 3:16-17; 2 Cor. 6:16), the church (Eph. 2:21; 2 Thess. 2:4; Rev. 3:12), and the kingdom of God (Rev. 11:1, 19; 15:5-8).

Threshold The threshold signifies the transition from one realm to another. In the Old Testament, the importance of the threshold was highlighted by God's precise instructions to the priest concerning the sacred ceremony of entering and leaving the holy place (Exod. 28:31-35). Entering and departing were to be clearly announced; failure to do

so warranted the death penalty. The Philistine god of agriculture, Dagon, had a temple whose threshold was not to be stepped on (1 Sam. 5:5). The people of God were to avoid the pagan practice of leaping over thresholds (Zeph. 1:9).

Tower The tower, because of its reach into the sky, is associated with the idea of linking heaven and earth. The Tower of Babel was a demonstration of humankind's mistaken belief that they could master the heavens (Gen. 11:4). Other variations of the tower in Christian tradition include the lighthouse, whose light guides the lost, and the citadel tower, which protects against the attacks of Satan. The Virgin Mary is sometimes referred to as the Tower of David, a reference drawn from the Song of Solomon (4:4). In church architecture, the tower has served as a symbol of God, who is a strong tower of refuge (Prov. 18:10). The tower is an attribute of Bernard of Aosta, Leocadia of Toledo, and Saint Barbara (who was imprisoned in a tower by her father).

Tree In Scripture, the tree is a symbol of both life and death. In the Garden of Eden there is both the tree of life and the tree of the knowledge of good and evil (Gen. 2:8-10). In the apocalyptic vision of John, the fruit from the tree of life (from which humankind was banned after the Fall — see Gen. 3:22-24) is offered to loyal followers of Christ (Rev. 2:7; 22:2, 14). In Christian iconography, the tree of life is frequently likened to the family tree of the root of Jesse. Legend has it that the tree of knowledge provided the wood for Christ's cross, which in effect returned Eden to humankind (Acts 13:29; Gal. 3:13). The tree can also symbolize life lived in accordance with God's will (Ps. 1:3).

Trumpet The trumpet is used symbolically as a signal of alarm or triumph (Isa. 27:13; Ezek. 33:3; Joel 2:1; Zech. 9:14; Matt. 6:2; 24:31; 1 Cor. 15:52; 1 Thess. 4:16; Rev. 1:10; 4:1; 8; 9:1-14; 10:7; 11:15). This may be the source of the use of *trumpet* as a verb, meaning "to spread good news." Christian depictions of the Last Judgment show angels blowing trumpets to announce the end of the world.

Unicorn The unicorn, a beloved symbol in art and literature, has roots that reach back to the Chaldeans and the Babylonians. This mythical creature is usually portrayed as white, with the body and head of a

horse, cloven hoofs, and a spiral horn growing out of its forehead. In Christian iconography, the unicorn is a symbol of purity and strength. According to legend, the unicorn could be caught only with the aid of a virgin, in whose lap the trusting animal sought refuge — a posture that enabled hunters to trap and kill the beast. This was seen as a symbol of the Virgin Mary's conception of Christ and of his subsequent arrest and crucifixion. In medieval lore, there are frequent references to the efficacy of the ground-up unicorn's horn as an antidote to poison (like the healing efficacy of the Savior's suffering — Isa. 53:4-5).

Urn The urn was introduced as a symbol of death during the Renaissance. It referred to the Roman custom of preserving the ashes after cremation of a body. As a universal symbol of containment, the urn corresponds to the world of the feminine and as such is the emblem of the Virgin Mary.

Veil/Veil of the Temple The veil is generally a symbol of modesty, virtue, and separation from the outside world (Gen. 24:65). The "literal" veil is made of cloth; clouds and fog are often referred to as veils. In Scripture, the veil signifies the concealment of aspects of truth or of God's glory (Exod. 26:33; 34:29-35; 36:35; 2 Cor. 3:14; 4:3). There were two curtains or veils in the Temple in Jerusalem, one at the entrance to the Holy Place and one at the entrance to the Holy of Holies. At the Crucifixion the veil of the Temple was rent (Luke 23:45), symbolizing the removal of the barrier between humankind and God through the blood of Christ (Heb. 10:19-20). This was a kind of revelation — an unveiling of the unknown and the mysterious.

A cloth veil functions as a covering for a person or a sacred object. A veil is used to cover a chalice when it contains the Blessed Sacrament. In some churches it is customary to veil crucifixes and pictures during Lent and Holy Week. Women in religious orders wear veils over their heads and shoulders. The veil is an attribute of Saint Veronica, Saint Agatha, and Saint Ludmilla.

Vessel The vessel is a symbol of containment and reception. Clay vessels are a metaphor for God's creatures, designed and made according to his creative plan and purpose (Isa. 29:16; 45:9; 64:8; Jer. 18:1-10; Rom. 9:21; 2 Tim. 2:20-21).

Vulture Medieval symbolists considered the vulture to be a sign of greed (one of the seven deadly sins) and lust. This connection can be traced back to the Greek myth of the giant Tityus, who was condemned to have his liver (the seat of the passions) torn by two vultures in hell. His crime was the attempted rape of the mother of Apollo. The theme recurs in Renaissance painting with the same meaning.

Walnut In Jewish tradition, Scripture was likened to a walnut. The shell corresponds to the historical facts; the nut refers to the substance of symbols and mysteries. Saint Augustine (A.D. 354-430) compared the walnut in its three substances to the redemptive work of Christ. The shell is the wood of the cross, the fruit surrounding the nut is the flesh of Christ with the bitterness of suffering, and the nut itself is the sweet interior of divine revelation that nourishes us.

Water Water is symbolic of God's blessing in the form of spiritual re-freshment and nourishment (Ps. 23:2; Isa. 32:2; 35:6-7; 41:18). Thirst often indicates a need for such refreshment (Pss. 42:1-2; 63:1: Amos 8:11). In Scripture, God is described as the fountain of living water (Jer. 2:13; 17:13; John 7:38). Water is also a symbol of the blessing of eternal life (John 4:14; Rev. 7:17; 21:6; 22:1, 17). It is related to the idea of cleansing from defilement and sin (Exod. 29:4; 30:18-21; Lev. 11:40; 15:5; 16:4, 24, 26; 17:15; 22:6; Num. 8:7; 19:1-10; Eph. 5:26; Heb. 10:22). Negatively, water is a symbol of danger and death, as in the Flood (Gen. 7); related is the fear of the sea and deep waters (Pss. 18:16; 32:6; 46:3; 69:1-2). Water is also an instrument of judgment (Isa. 43:2; 59:19).

Ceremonially, the church uses water for baptism, aspersion (the sprinkling of congregants with holy water), and foot-washing (John 13:5). In the Roman Catholic Church, drops of water are also added to the wine used in the Eucharist. The water symbolizes the people, and the wine symbolizes Christ, the two united by his sacrifice. This Eucharistic use of wine and water is a reference to the blood and water that flowed from Christ's side at the Crucifixion. Holy water, impor-tant in the Roman Catholic Church, is water blessed by a priest and used liturgically as a sign of blessing. Believers bless themselves with holy water at the entrance to a church, and the celebrant of the Mass symbolically sprinkles all present before the High Mass. This blessed water is also used in dedications, exorcisms, and burials.

Well As a source of life-giving water, the well is associated symbolically with baptism and eternal life (John 4:1-27). In the Celtic regions of Europe, wells that were originally centers of pagan cult rituals were changed into Christian shrines. The festival practice of dressing the well with garlands or flowers and a crucifix or image of the Virgin Mary continues today. Some of these wells became pilgrimage centers because of the belief that their waters had curative powers (e.g., Muswell Hill in London, Shadwell in Yorkshire, and Walsingham in Norfolk).

Willow The weeping willow is a symbol of grief and death. Occasionally it appears in paintings of the Crucifixion. The willow is also a symbol of the gospel of Christ, which, like the willow, continues to flourish no matter how many of its branches (messages of good news) are cut and distributed among the nations.

Windows In Christian iconography, windows that admit supernatural light are symbols of divine revelation, representing the penetration of the earthly by the heavenly. (In Malachi 3:10, the "windows of heaven" are a conduit of blessing.) In depictions of the Annunciation, a supernatural beam of light passes through a window to the Virgin Mary. (A powerful example is Robert Campin's *Merode Altarpiece,* c. 1420-30.) In Gothic church architecture, the stained-glass window transformed the everyday light of the outside into an otherworldly light in the church's interior.

Winepress The winepress is a symbol of God's wrath (Isa. 63:3). In the Middle Ages, Christ (as the bearer of our sins and thus the recipient of God's wrath) was depicted crushed under the winepress, issuing forth wine that symbolized his blood (Isa. 53:5). Augustine also likened Christ to grapes that had been crushed in the winepress.

Wolf The first Christian symbolists of Rome associated the wolf with evil, particularly the sins of avarice, greed, and lust. Christ's description of false prophets as "wolves in sheep's clothing" has led to the association of the wolf with heretics and hypocrites — particularly members of the clergy false to their calling (Matt. 7:15). In his parable of the Good Shepherd, Christ identified the wolf as the enemy of his spiritual flock

(John 10:11-12). In his *Divine Comedy,* Dante represented the concupiscence of the flesh with a female wolf.

Worm The worm represents the humiliation of a person or group, the insignificance of human existence when compared to that of God (Job 25:6; Isa. 41:14; 66:24).

Wormwood Wormwood is a plant that yields a bitter extract used in making absinthe and in flavoring certain wines. The taste of wormwood is a poetic description of the bitterness and pain of judgment (Jer. 9:15; 23:15; Lam. 3:19; Rev. 8:10-11).

Wounds At the Crucifixion, Christ received five wounds, one on each hand and foot and one in his side. Tradition has established that the pattern of these wounds sometimes manifested themselves among the saints, the most notable being Saint Francis of Assisi. These marks are called stigmata (plural of the Greek *stigma,* meaning "tattoo"). The five wounds are represented in the "fair linen" (a cloth covering the top of the altar): one in each corner and one in the center.

Wreath The meaning of the wreath depends on what it is made with: laurel leaves signify victory, oak leaves symbolize strength, yew branches symbolize immortality, and cypress leaves communicates mourning. An Advent wreath is usually made of holly (see "Holly" above). In Christian art, angels hold a wreath as they prepare to place it on a saint's head. The victory wreath of antiquity, which was made of laurel leaves, came to designate the attainment of salvation, and consequently it appears on gravestones, occasionally with the Christ monogram, the Dove, or the Lamb.

— V —

Glossary of Colors and Numbers

Colors

Black Black is a color symbolizing mourning or grief (Isa. 50:3; Jer. 4:28). It is also asociated with solemnity, negation, sickness, and death. Black is inherently ominous in that it represents the unknown, a feature it shares with death. In the apocalyptic literature of Scripture, the black horse represents the ravages of hunger (Zech. 6:2-6; Rev. 6:5-6).

Blue The color blue represents many things: heaven, infinity, spiritual love, truth, constancy, and fidelity. The Virgin Mary is often depicted wearing a blue robe, although the liturgical color was fixed as white in the sixteenth century. Cerulean blue, the color of the sky on a sunny day, has a natural symbolic connection to heaven.

Brown and Gray These are lifeless colors, the color of ashes. They are commonly used in religious habits to signify mortification, mourning, and humility. The colors are also used by many mendicant orders to signify poverty.

Gold and Yellow These colors almost universally symbolize the sun as well as divine illumination, purity, immortality, and wisdom. In the Christian tradition, they are used primarily to represent purity, divinity, and kingship. In Eastern Orthodoxy, gold represents perfection and the light of heaven, as demonstrated by medieval panels and icons.

But this color doesn't always have positive associations. The idolatrous worship of the golden calf (Exod. 32) symbolizes materialism and the love of money, the mammon of unrighteousness (Luke 16:9). Yellow also signifies deceit, jealousy, instability, cowardice, or treason. Yellow was the color of heretics in the Middles Ages. Judas is often depicted wearing yellow.

Green Green is a liturgical color symbolizing growth, fertility, life, and hope. It is the color commonly used (for vestments, stoles, and altar and pulpit cloths) on the Sundays following Epiphany and leading up to Lent, and then again after Trinity Sunday.

Purple/Violet These are liturgical colors that represent sorrow and penitence. Purple is used for the penitential seasons of Advent and Lent, although rose may be used on Gaudete Sunday (the third Sunday in Advent) and Laetare Sunday (the fourth Sunday in Lent). In religious paintings, Mary Magdalene usually wears violet as a sign of penitence. In depictions of the Crucifixion, the Virgin Mary wears a violet robe as a sign of sorrow. In Scripture, purple is also an indication of costly quality (Prov. 31:22) and is frequently associated with royalty and high officials (Judg. 8:26; Esther 1:6; 8:15; Ezek. 23:6).

Red/Scarlet Red represents the sacrificial blood of Christ and the blood of martyrs (2 Kings 3:22-23; Rev. 6:4). Sin is also symbolized by the color red (Isa. 1:18). In Revelation, red is the color of Satan, the great dragon (Rev. 12:3); it suggests his power and murderous nature. Babylon the Great, the "mother of whores and of earth's abominations," rides upon a scarlet-colored beast (17:3-5).

In liturgical use, positive associations with red are seen in depictions of the Creator and the risen Christ. Red vestments are worn on feast days, on memorial days of martyrs, and on Pentecost. Red recalls the Pentecostal tongues of fire as well as Christ's Passion on Good Friday and Passion Sunday.

In popular use, red is the color of love. In Christian art, John is often depicted in red to suggest love in action.

Silver In biblical language, refined silver symbolizes the purification of the soul (Ps. 66:10) and the pure, proven promises of God (Ps. 12:6).

White White usually represents purity (Ps. 51:7; Isa. 1:18; Dan. 12:10) and holiness. In Scripture, white garments frequently suggest this. On the Day of Atonement, the high priest (Aaron) is instructed to put on "the holy linen tunic" (Lev. 16:4, 32). God sits on a white throne and is clothed in white (Dan. 7:9; Rev. 20:11), as is Christ at his transfiguration (Matt. 17:1-2; Mark 9:3). Also clothed in white are the angel at the tomb (Matt. 28:2-3); the "overcomers" and the twenty-four elders in Revelation (3:4-18; 4:4; 7:9, 14; 19:8); and the seven angels (Rev. 15:6).

White is the liturgical color of vestments worn from Holy Sunday until the feast of Pentecost. It is the color for the joyous celebrations of Christmas, Easter, and the Feast of the Ascension, as well as for services related to the celebration of the Eucharist.

Numbers

One One is a symbol of unity. It is used to describe God in Deuteronomy: "Hear, O Israel: The Lord our God, the Lord is one" (6:4, NIV). In the New Testament this declaration is quoted by Jesus when he is asked to name the most important commandment (Mark 12:29-30).

Two Two is a symbolic number for pairs or the double nature of something. Two of every kind of creature were saved in the Ark (Gen. 6:19), and Christ has a twofold nature (divine and human).

Three Three is the most frequently used of Christian symbolic numbers. It is primarily a reference to the Trinity (Luke 3:22; John 14:16). In Christian art and architecture, threefold elements, such as a three-part window, a trefoil, and a triangle, usually symbolize the Trinity. Other significant "threes" in Scripture are these: the three days Jonah spent in the belly of the great fish (Jon. 1:17); the three days Christ lay in the tomb (Matt. 12:40; Mark 8:31; John 2:19); the three virtues — faith, hope, and love (1 Cor. 13:13); and the three gates on each side of the New Jerusalem (Rev. 21:13).

Four Four is the primary number of earth, referring to the four corners of the globe and the four elements (earth, air, fire, and water). In

Scripture there are the Four Evangelists (Matthew, Mark, Luke, and John); the four major prophets (Isaiah, Jeremiah, Ezekiel, and Daniel); the "four living creatures" of Ezekiel (1:5; cf. Rev. 4:6); and the four horsemen of the Apocalypse (Rev. 6:2, 4-5, 8). According to Babylonian tradition, Paradise was watered by four rivers — the Pishon, the Gihon, the Tigris, and the Euphrates — and these rivers came to symbolize the Gospels during the Middle Ages. In his *Republic,* Plato formulated four cardinal virtues: justice, prudence, fortitude, and temperance. In eschatology the Four Last Things are Death, Judgment, Heaven, and Hell.

Five Five is a significant symbolic number relating to the Passion of Christ. It refers to the five wounds Christ suffered at his crucifixion.

Six From antiquity through the Middle Ages, six was regarded as the perfect number because it can be represented as the sum of its parts and as their product ($1 + 2 + 3 = 6$ and $1 \times 2 \times 3 = 6$). Six stands for the perfect attributes of God — power, majesty, wisdom, love, mercy, and justice — and for the six acts of mercy (Matt. 25:35-36). In Revelation the "four living creatures" surrounding the heavenly throne each have six wings (4:8), but the number six also figures in "the mark of the beast" — 666 (Rev. 13:16-18).

Seven In biblical numerology, seven is the most significant of sacred numbers. It is the number of completeness, fullness, and perfection. Numerous references to seven are found in Scripture. Important representative examples abound. There are the seven days of creation referred to in Genesis (2:1). Joshua and his men marched around Jericho seven times before the city's walls fell (Josh. 6:4-5). Naaman bathed seven times in the Jordan in order to "restore his flesh" (2 Kings 5:10-14). The people of Israel observed the Feast of Booths on the fifteenth day of the seventh month, feasting for seven days and then living in booths for seven days (Lev. 23:33-44). Every seventh year they observed as a "sabbath" when they did not work the land, and every forty-nine years (seven times seven) they observed the Year of Jubilee (Lev. 25). The golden candlestick of the Jewish temple had seven branches. In the book of Revelation, there are seven churches, seven candlesticks, seven stars, seven trumpets, and seven spirits before the throne of God.

In medieval Europe there was a predilection for establishing series

of seven — the seven virtues, the seven arts and sciences, the seven sacraments, the seven ages of man, and the seven deadly sins.

Eight The figure eight is a spiraling shape ever in motion; thus it is the number of regeneration. Baptismal fonts are often octagonal, representing the seven days of creation and the eighth day of regeneration. Eight also represents Christ's resurrection, because on the eighth day after his entry into Jerusalem, he arose from the grave.

Nine The number nine is an amplification of the sacred number three ($3 \times 3 = 9$), the number of completion and eternity. This is the basis for the liturgical form of the Kyrie eleison (meaning "Lord, have mercy"), repeated nine times. Tradition numbers nine choirs of holy angels and nine cosmic spheres. In Scripture, there are nine fruits of the Holy Spirit (Gal. 5:22).

Ten In antiquity the number ten was considered a perfect number because it contains within itself all numbers between one and nine. The Pythagoreans considered ten a holy number, the embodiment of perfection and harmony, because it is the sum of the numbers one, two, three, and four. This perfection is exemplified in the Ten Commandments (Exod. 20).

Twelve Twelve is one of the most important numbers in biblical times. Its significance stems from the number's importance in the culture of the ancient Near East, where there were twelve months in the calendar year, and twelve was important in the numbering system. In Scripture, the importance of twelve derives from the emergence of the twelve tribes of Israel, mentioned in Genesis (49:28). Throughout the rest of the Old Testament, twelve is a key measurement.

 The significance of twelve carries over into the New Testament with Jesus' appointment of the twelve apostles (Mark 3:14), and continues through the book of Revelation. Among those saved are twelve thousand persons from each of the twelve tribes of Israel (7:5-8). The woman "clothed with the sun," representing Israel, is crowned with twelve stars (12:1-2). The holy city has twelve gates and twelve angels as gatekeepers (21:12). The tree of life in the holy city bears twelve kinds of

fruit every month; the tree's leaves are for "the healing of the nations" (22:2).

Forty Forty is a symbolic number denoting a period of endurance, testing, and probation. The many examples include the length of the Flood (Gen. 7:4); the number of days that Moses spent on Mount Sinai (Exod. 24:18); the number of years the Israelites wandered in the wilderness (Exod. 16:35; Num. 14:33); the number of days that the people of Nineveh were given to repent (Jon. 3:1-5); the number of days that Christ fasted in the wilderness (Matt. 4:2); and the number of days that Christ was on earth after his resurrection (Acts 1:3). Lent (from the Old English *lencten,* meaning "spring"), the season observed before Easter, consists of forty days (excluding Sundays) of fasting, abstinence, and penitence, recalling the forty days Christ spent in the wilderness.

Seventy As the product of 7 × 10, seventy is an amplification of the holy number of seven. It appears numerous times in Scripture. According to the psalmist, it is the average lifespan (Ps. 90:10). It is also the number of years the Jews spent in Babylonian captivity (Jer. 25:12). In the New Testament, Luke presents the unique account of Jesus' appointing seventy disciples who, in addition to the Twelve, are sent on a mission (Luke 10:1). Most well-known, perhaps, is Jesus' answer to Peter when he asks how many times he should forgive someone who offends him: "seventy times seven" (Matt. 18:22). In the third and second centuries B.C., approximately seventy scholars translated the Jewish Scriptures into Greek — hence the name Septuagint (from the Latin meaning "seventy").

— VI —

The Church Calendar

The Christian calendar is essentially an inheritance from the Jewish culture of the Old Testament. The Jewish calendar was based upon the lunar cycle. It is from this calendar that the Christian Church took the concept of feasts and holy seasons, like the Passover and Pentecost, being fixed according to the moon's phase. The Christian calendar is complicated by the fact that it's based both on the Jewish calendar and on the Roman solar calendar, which has a fixed movement. This explains why the Christian year has "movable" and "fixed" feasts. In practice the movable feasts, such as Easter, follow the Jewish calendar, while the fixed feasts of Christmas and Epiphany follow the Roman calendar.

The earliest Christian calendar extant is from the fourth century. The earliest calendar of the Church of England dates from the eighth century and has been attributed to the Venerable Bede.

After the Reformation, Lutherans, like Anglicans, retained the general framework of the Christian calendar and continued to observe the more important feasts. Calvinists, by contrast, kept only the Lord's Day and discarded all other commemorations. Calvin abandoned the calendar for two reasons. He objected to the medieval practice of the invocation of the saints, and he disliked the irreligious and superstitious popular practices associated with the observances.

In recent times there has been a growing appreciation of the value of the Christian calendar and a renewal of its observance, even among the Reformed traditions that trace their roots to Calvin.

Advent

Advent begins the Christian year. It is the season of looking forward. Christians prepare for Christ's birth at Christmas; we proclaim his future ministry, as did John the Baptist; and we watch expectantly for his second coming. We anticipate the joy of his first coming, but also the judgment of his second coming. So we look forward in both happiness and penitential preparation. This period begins four Sundays before Christmas Day.

Some churches use blue as the Advent color — the color associated with the Virgin Mary. But the most common liturgical color for Advent is purple, the color of penitence but also the color of royalty, signaling the coming of the King of Kings.

Christmas

During the season of Christmas we rejoice in Christ's birth. On Christmas Day we celebrate "the good news of great joy" that we read about in Luke: "To you is born this day in the city of David a Savior, who is the Messiah, the Lord" (2:10-11). The period from Christmas Day through the Sunday following makes up the season of Christmas. White is the color universally used for Christmas through the first Sunday of Epiphany.

Epiphany

The Epiphany (from the Greek word meaning "manifestation") is celebrated on January 6, in commemoration of the manifestation of Christ to the Gentiles. The Magi who visited the Christ child are seen as representative of all the non-Jews to whom Christ came. This celebration begins the Epiphany season — the Sundays following the last Sunday of the Christmas season up until Lent. Candlemas, which commemorates the presentation of Christ in the temple, is held on February 2. The color green is used throughout the Epiphany season, up until Lent.

Within the Epiphany season, some traditions observe a pre-Lenten season, which lasts for three and a half weeks, from Septuagesima Sunday, as it is called, to Ash Wednesday. This is a time of preparation for Lent.

Lent

Jesus' preparation for his ministry began with forty days of fasting and prayer in the wilderness. Although tempted by Satan, Jesus chose instead the way of the Cross. The forty-day Lenten season commemorates this event.

The Tuesday before the beginning of Lent has traditionally been observed by a carnival (which means "to put away flesh"), the most famous being Mardi Gras ("Fat Tuesday").

Ash Wednesday marks the beginning of Lent. In the rite for Ash Wednesday that some traditions observe, ashes (made by burning the palm leaves that were blessed on Palm Sunday of the year before) are placed upon the altar, blessed, sprinkled with holy water, and censed. The congregants then kneel, and the priest touches each of their foreheads with the ash, saying, "Remember, O man, thou art dust, and unto dust thou shalt return."

There are six Sundays in Lent, concluding with Palm Sunday, which ushers in Holy Week, commemorating the death and burial of Christ. The Thursday of Holy Week, called Maundy Thursday, commemorates the institution of the Lord's Supper. It is a time of remembering — and in some places re-enacting — Jesus' washing of the disciples' feet during that Supper. In the Episcopal Church it is common practice to strip the altar and ceremonially wash it with water or wine. The whole life of the church has dwindled to its lowest point before the catastrophe of Good Friday.

Good Friday is a day when the church observes fasting and humiliation in sorrow for the death of Christ and the sin that brought it about.

Holy Saturday is the last day of Holy Week (also known as Easter Even). In ancient times this was a day spent in solemn fasting until midnight, when the Lenten fast ended and the Easter vigil began. Many

liturgical churches now hold an evening vigil culminating in the celebration of the midnight mass.

Purple, the color of penitence, is used for Lent, which is replaced by white on Easter.

Easter

Easter is the oldest of the Christian festivals — the feast of feasts, the most joyous of Christian observances. It is the time to commemorate the resurrection of Christ and the restoration of life to the world in which sin brought death. In many Christian traditions it is the great day for baptism, a symbol of the believer's identification with Christ in his death, burial, and resurrection. Included in the Easter season are the five Sundays after Easter, leading to Ascension Day (Holy Thursday), which is usually observed on the fifth Thursday — the fortieth day — after Easter. Some traditions have their celebration on the following Sunday, known as "Expectations Sunday" (since it looks forward to Pentecost). White continues to be used on this Sunday.

Pentecost

The season of Pentecost or Whitsuntide corresponds to the Jewish Festival of Weeks or Pentecost in the same way that the Christian Easter corresponds to the Jewish Passover. Pentecost is the second most important festival of the Christian year, after Easter. This season lasts until the last week of November, when the Christian calendar begins again with Advent. Just as this is a time for crops to grow and mature, so this is a time for believers to grow and mature in their faith.

The color for the entire Pentecost season is red, although many traditions use green on the Sundays beginning at Trinity Sunday and continuing to the first Sunday of Advent. In Protestant churches, red usually replaces the green on Reformation Sunday.

Selected Bibliography

Apostolos-Cappadona, D. *Dictionary of Christian Art.* New York: Continuum, 1994.

Appleton, L., S. Bridges, and M. Lavanoux. *Symbolism in Liturgical Art.* New York: Scribner's, 1959.

Becker, Udo. *The Continuum Encyclopedia of Symbols.* Translated by Lance W. Garner. New York: Continuum, 1994.

Belting, Hans. *Likeness and Presence: A History of the Image before the Era of Art.* Translated by Edmund Jephcott. Chicago: University of Chicago Press, 1994.

Biedermann, H. *Dictionary of Symbolism.* Translated by James Hulbert. New York: Facts on File, 1992.

Bradner, J. *Symbols of Church Seasons and Days.* Wilton, Conn.: Morehouse-Barlow Co., 1977.

Campbell, J. *Historical Atlas of World Mythology.* New York: Harper & Row, 1988.

Charbonneau-Lassay, L. *The Bestiary of Christ.* Translated and abridged by D. M. Dooling. New York: Parabola Books, 1991.

Chevalier, J., and A. Gheerbrant. *Dictionary of Symbols.* Translated by John Buchanan-Brown. New York: Penguin Books, 1996.

Cirlot, J. E. *A Dictionary of Symbols.* New York: The Philosophical Library, 1972.

Davis, J. *Biblical Numerology.* Grand Rapids, Mich.: Baker Book House, 1968.

Didron, A. N. *Christian Iconography: A History of Christian Art in the Middle Ages.* 2 vols. New York: Ungar, 1965.

Eliade, M. *Symbolism, the Sacred, and the Arts.* Edited by Diane Apostolos-Cappadona. New York: Continuum, 1992.

Ferguson, G. *Signs and Symbols in Christian Art.* New York: Oxford University Press, 1961.

Finney, P. C. *The Invisible God: The Earliest Christians on Art.* New York: Oxford University Press, 1994.

Fleming, D. J. *Christian Symbols in a World Community.* New York: Friendship Press, 1940.

Fontana, D. *The Secret Language of Symbols.* San Francisco: Chronicle Books, 1994.

Forstner, D., and R. Becker. *Neues Lexikon Christlicher Symbole.* Innsbruck: Veriaganstalt Tyrolia, 1991.

Frutiger, A. *Signs and Symbols: Their Design and Meaning.* Translated by Andrew Bluhm. New York: Van Nostrand Reinhold, 1989.

Frye, N. *The Great Code: The Bible and Literature.* New York: Harcourt Brace Jovanovich, 1982.

Gibson, C. *Signs and Symbols: An Illustrated Guide to Their Meaning and Origins.* New York: Barnes and Noble Books, 1996.

Grabar, A. *Christian Iconography: A Study of Its Origins.* Princeton: Princeton University Press, 1968.

Hall, J. *Dictionary of Subjects and Symbols in Art.* New York: Icon Editions, 1979.

————. *Illustrated Dictionary of Symbols in Eastern and Western Art.* New York: Icon Editions, 1995.

Hammond, P. *Liturgy and Architecture.* New York: Columbia University Press, 1961.

Hulme, F. E. *The History, Principles, and Practice of Symbolism in Christian Art.* New York: Macmillan, 1910.

Jung, C. G., with Joseph L. Henderson, Marie-Louise von Franz, and Aniela Jaffe. *Man and His Symbols.* London: Penguin Books, 1964.

Lane, B. *The Altar and the Altarpiece.* New York: Harper & Row, 1984.

Lathrop, G. *Holy Things: A Liturgical Theology.* Minneapolis: Fortress Press, 1993.

Maguire, H. *The Icons of Their Bodies: Saints and Their Images in Byzantium.* Princeton: Princeton University Press, 1996.

Male, E. *The Gothic Image.* New York: Harper, 1958.

Metford, J. C. J. *Dictionary of Christian Lore and Legend.* London: Thames and Hudson, 1993.

Morgan, D., editor. *Icons of American Protestantism: The Art of Warner Sallman.* New Haven: Yale University Press, 1996.

Murray, P., and L. Murray. *The Oxford Campanion to Christian Art and Architecture.* New York: Oxford University Press, 1996.

Nichols, A. (O.P.). *The Art of God Incarnate: Theology and Image in Christian Tradition.* New York: Paulist Press, 1980.

Panofsky, E. *Studies in Iconology: Humanistic Themes in the Art of the Renaissance.* New York: Harper & Row, 1962.

Post, W. E. *Saints, Signs, and Symbols.* 2d edition. Harrisburg, Pa.: Morehouse Publishing, 1990.

Ryken, L., J. Wilhoit, and T. Longman III. *Dictionary of Biblical Imagery.* Downers Grove, Ill.: InterVarsity Press, 1998.

Schiller, Gertrud. *Iconography of Christian Art.* Vols. 1 and 2. Greenwich, Conn.: New York Graphic Society Ltd., 1971.

Schonborn, C. (O.P.). *God's Human Face: The Christ Icon.* Translated by Lothar Krauth. San Francisco: Ignatius Press, 1994.

Sill, G. G. *A Handbook of Symbols in Christian Art.* New York: Macmillan–Collier Books.

Ugolnik, A. *The Illuminating Icon.* Grand Rapids, Mich.: Eerdmans Publishing Co., 1989.

Webber, F. R. *Church Symbolism.* Cleveland: J. H. Jansen, 1938.

West, Canon E. N. *Outward Signs: The Language of Christian Symbolism.* New York: Walker and Co., 1989.

Index of Subjects

Index of Subjects

Index of Scripture References